MASTERING CALLIGRAPHY

TIMOTHY NOAD

Calligraphy

MASTERING
CALLIGRAPHY

TIMOTHY NOAD

JG
PRESS

Conceived, designed and edited by
The Bridgewater Book Company Ltd

Designer Terry Jeavons
Editor Margaret Crowther
Managing Editor Anna Clarkson
Photography Nelson Hargreaves
Typesetter Ginny Zeal
Cover calligraphy Carol Kemp

3547
Published in the USA 1996 by JG Press
Distributed by World Publications, Inc.
Copyright © 1995 by CLB Publishing
Godalming, Surrey, UK
Printed and bound in Singapore
ISBN 1-57215-189-7

The JG Press imprint is a trademark of JG Press, Inc.
455 Somerset Avenue
North Dighton, MA 02764

The author would like to thank Gaynor Goffe for providing all the left-handed material,
and examples; Frederick Marns, copperplate alphabet; Rachel Yallop,
freely written capitals; Patricia Lovett, letters in a variety of styles and materials; Ruth Sutherland,
Runic-style versals; Christine Marr, uncial variations and modernized versals;
and Carol Kemp, Gothic variations, Eastern style, informal, decorated Lombardic,
italic variation and some miscellaneous letterforms

Contents

How to use this book

The first part of the book puts calligraphy – the art of beautiful writing – into historical perspective and describes how writing developed out of drawing, to become an art in its own right.

A separate section explains how left-handed people can adapt the techniques and find a comfortable writing position which will enable them to produce their own beautiful work.

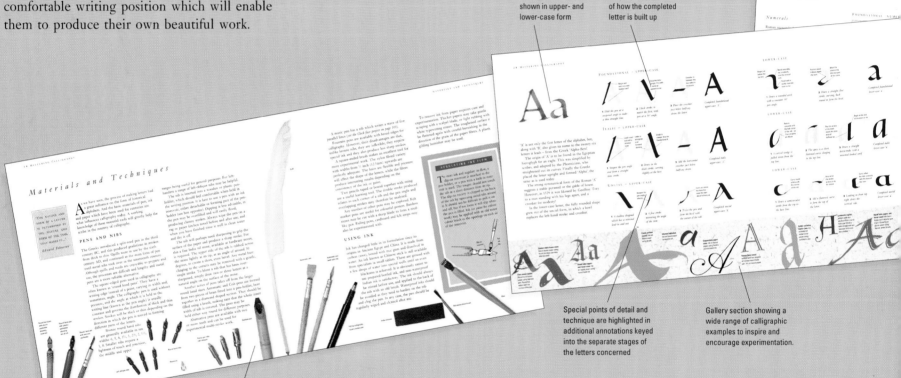

Each letter is shown in upper- and lower-case form

Step-by-step breakdown of how the completed letter is built up

Special points of detail and technique are highlighted in additional annotations keyed into the separate stages of the letters concerned

Gallery section showing a wide range of calligraphic examples to inspire and encourage experimentation.

MATERIALS AND TECHNIQUES

Sets out for beginners what basic (and very simple) equipment will be needed, and describes how to set up a work station and how to get started. The techniques of using colour and gilding are described, as well as using calligraphy pens and ink.

A–Z STEP BY STEP

The main part of the book gives three alphabets which will form the basis for creative calligraphy. Each letter of the alphabet has a complete double-page spread.

Numerals, and the finishing touches, such as flourishes, serifs and accents, are explained in the same detailed way at the end of the A–Z.

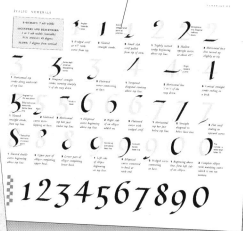

Box which gives a tip for left-handers These tips build up to form a set of helpful and practical left-handers' guidelines. There are very few problems that are specific to left-handers, once the general approach has been mastered, with the help of these tips

Simple to follow step-by-step instructions

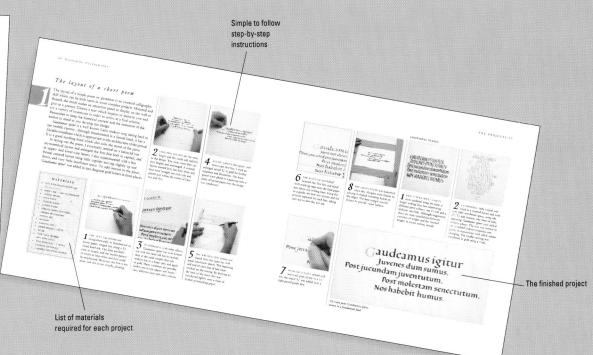

The finished project

List of materials required for each project

STEP-BY-STEP PROJECTS

Finally, a set of simple but creative projects gives scope for practising the art of calligraphy. The idea is not so much to follow instructions step by step, but to see how a calligraphic design is built up and developed, so that the newly skilled calligrapher can explore for himself or herself the creative possibilities of this absorbing art.

The origins and development of calligraphy

Writing developed out of art. The earliest cave paintings, dating from around 25,000 BC, can be seen as a pictorial means by which artists recorded and told stories of the animals they hunted. Gradually images became less representational and more symbolic, but it was several millennia before a system of symbols began to be used to represent ideas and a language.

PICTOGRAMS AND IDEOGRAMS

The first known writing was developed by the Sumerians who inhabited the fertile plain of Mesopotamia between the Tigris and Euphrates rivers from about 3,500 BC. They formed an efficient agricultural society, with a government, monetary system and craftsmen. The first texts were inscribed into tablets of river clay, using sharpened reeds, and the tablets were then baked. Among the earliest tablets to survive are lists depicting sacks of grain and heads of cattle. Later, religious and social structures were recorded.

Sumerian characters are a series of simplified pictograms depicting various objects. They are formed from straight lines, and wedge-shaped serifs, called *cuneae* in Latin, giving rise to the term 'cuneiform'. As the system developed, some pictograms became ideograms representing more abstract concepts. For example, a human foot could, depending on the context, both mean 'to stand up' or 'to walk'. Eventually these images were also related to spoken sounds to form phonograms, standing for syllables with a similar sound to the word for the object shown. By these means some 2,000 symbols were reduced to 600.

In 1720 BC, the Babylonians overran Sumer and took on the cuneiform system, using it to record their history, religion, literature and other branches of learning. In their turn, the conquering Assyrians adopted and spread cuneiform to other Semitic tribes of the Middle East.

Meanwhile, in Ancient Egypt, settlers on the banks of the Nile had established a civilization with its own system of writing. The term 'hieroglyphics' derives from the Greek for 'sacred engraved writing' and denotes the engaging pictorial symbols used for religious and monumental purposes. A more quickly written or 'cursive' stylization of the signs was known as 'hieratic' script, and an even freer version called 'demotic' was used for everyday purposes. Unlike the precisely carved or painted

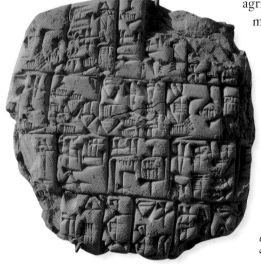

BELOW *This typical cuneiform tablet from Sumeria dates from the third millenium BC. The angular characters were inscribed in wet clay using a stylus.*

ABOVE *The Ancient Egyptians used over 5000 hieroglyphs based on symbolic representations.*

RIGHT *The signs of the Phoenician alphabet are recognizable as letters, rather than the pictorial symbols from which they developed.*

hieroglyphs, the demotic script was written rapidly with a reed brush, this influencing its flowing character. The usual writing surface was papyrus, a criss-cross mat of beaten plant stems, giving us our word 'paper'. Ink was, as it remains today, a mixture of carbon (soot), water and a gum binder. The Egyptian writing system hardly changed from 3,000 BC until 390 AD, for although a true alphabet of twenty-four consonant signs developed, some 5,000 superfluous symbols were still retained.

Independently, the ancient Chinese also invented a pictogram system to be used as phonograms for their monosyllabic words. To differentiate similar sounds, each sign has an ideogram added. From 2–3,000 characters, a system capable of representing some 5,000 words was established by the first century BC.

EARLY ALPHABETS

By the tenth century BC, the first workable alphabet, in which arbitrary symbols represented individual sounds, had been invented by the Phoenicians, who were originally a Syrian people, but who established a culture trading in exotic goods throughout the Mediterranean. They borrowed written elements from several sources – cuneiform, hieroglyphics and the now indecipherable Minoan script of ancient Crete, Linear A, dating from the fifteenth century BC. The twenty-four letters of their alphabet, all representing consonant sounds, bore little relation to their pronunciation or symbol of origin, and were written into clay tablets using the point of a stylus.

The Phoenicians were an Aramaic-speaking people, along with the Semitic Hebrews and Arabs, who also developed alphabets from cuneiform and Egyptian origins, and the roots of our own ABC were established in this area. Aramaic script was used for the Dead Sea Scrolls, the earliest surviving Biblical manuscripts, which were written on leather.

THE GREEKS & ROMANS

By around 850 BC, the Greek peoples had adopted some of the Phoenician consonants, with the addition of vowels which they needed for their own language (these were mostly based on redundant Phoenician letters). This was standardized into Ionic script by 403 BC, comprising seventeen consonants and seven vowels. The angularity of Greek capital letters betrays their origins, inscribed with a stylus onto a wax tablet, or carved in stone. A 'lower-case' form written with a reed pen on papyrus was also developed. As the pen met resistance when pushed from right to left on rough papyrus and only delivered ink when pulled from left to right, the Greeks began to write in this direction. (Previously, writing had always been done in the opposite direction, as is still true for Hebrew and Arabic scripts.) Letter spacing, important to an aesthetically minded culture, now improved as the hand no longer covered the writing.

By the second century BC, parchment was invented as an alternative to expensive Egyptian papyrus, reputedly at Pergamon as its name implies. From then until paper became popular in the late Middle Ages, prepared skins of sheep, cattle and goats were the favoured writing surface.

FAR RIGHT *Trajan's column (113 AD) shows perfectly the Roman capitals, well formed, well proportioned, and beautifully spaced.*

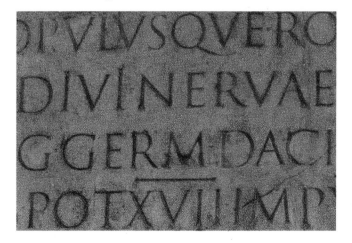

Either via the influence of the Etruscans, whom they displaced, or from direct contact, the early Romans adopted the Greek alphabet. They adapted it for the Latin language, using many letters unchanged, with others altered and some obsolete forms revived.

CAPITALS AND RUSTICS

The diverse Roman letter shapes were unified into a balanced and dignified series by subtle manipulation of form, reaching a peak of excellence in the lettering of Trajan's column of 113 AD. The finely proportioned *capitalis monumentalis* were written with a square-cut brush and chiselled into stone or marble. These square capitals were less suited to expensive vellum and papyrus, however, by reason of their wide spacing and monumental forms, and for this medium a compressed version called *capitalis rustica* or rustics was used. For business and personal transactions, a third, less formal, rapidly written type of Roman capitals became popular. Spread by invading armies throughout Europe, the Roman scripts influenced all later forms and remain in use today.

UNCIAL SCRIPTS

In 311 AD, Constantine proclaimed Christianity the official religion of the Roman Empire. For the first time, the dissemination of a sacred text was of prime importance, and copies of the Bible were now transcribed in 'Codex' form, bound between covers on vellum pages, rather than written on scrolls which had hitherto been used for writing. The script used, uncial, was the dominant script from the fourth to the eighth centuries. The flattened angle of the pen, usually a square-cut goose quill, formed naturally rounded letters with, for the first time, short ascenders and descenders. It was spacious and majestic, but slow to write, so a speedy script had to be developed for

economy: half-uncial, a combination of formal and informal Roman hands, and the earliest true minuscules (smaller, non-capital, letters).

As the Roman Empire split, different areas became independent and developed their own languages and scripts; in southern Italy, Beneventan; in Spain, Visigothic and in the Frankish Empire, Merovingian. Scripts became increasingly decorated (illuminated). Ireland was visited by missionaries who introduced Roman half-uncials. The native Celts adapted these and, as monasticism developed from about 400 AD,

FAR RIGHT Thanks to the dedication of Irish–British monks, the arts of calligraphy and illumination flourished in Ireland and Northumbria from the fifth century onwards, and works such as the Book of Kells *(early eighth century) were produced.*

used them for intricately decorated manuscripts which reached their apotheosis in the *Book of Kells* (*c*.700 AD). The Irish undertook missions to Iona and Northumbria, spreading their so-called 'insular' script, which flourished in such works as the *Lindisfarne Gospels* (*c*.698 AD). In southern England, at the beginning of the seventh century, the missionaries of St Augustine introduced their own rustics and half-uncials, but the Irish–British 'insular' hand, a pointed style based on cursive handwriting, continued to predominate until the tenth century.

CAROLINGIAN MINUSCULES AND THE FOUNDATIONAL HAND

Europe was eventually reunited under Charlemagne, who assumed total control in 771 AD. He was warlike but a good administrator and assembled a cultured court at Aachen. Through the reform of church and state and an interest in the classical past, it became necessary to copy many texts, and a scriptorium was set up at Tours under Alcuin of York. Here a new style of writing was developed – the Carolingian minuscule. This featured rounded letters and arches, with some cursiveness (flowing style and joining of letters) and a slight forward slope. It could be rapidly written and took up little precious parchment.

Carolingian forms the basis of future lower-case alphabets including the italic hands and printed 'roman' type. Through the spread of Charlemagne's empire its influence was wide and pervasive. In England it came late, in the tenth century. But it was the decisive forms of the Ramsey Psalter, *c*.980 AD, that provided the inspiration for Edward Johnston's 'foundational hand' in the early twentieth century – the main teaching script of calligraphy.

In Carolingian manuscripts a hierarchy of scripts became the fashion. For the illuminated initials Roman

square capitals were used. This continued throughout the Middle Ages, although the forms of the letters altered. Originally known as 'versals', as each began a verse of the Bible, they became more decorative and exaggerated and the 'Lombardic' alphabet was created. The headings of early manuscripts were written in rustic capitals. Next in the hierarchy were uncials, used for the first line of text. Finally, the main body of the page was composed of minuscules.

THE GOTHIC ERA

As the rounded arches of Carolingian letters reflect the architecture of the time, so when the angular and pointed styles of Gothic architecture appeared, lettering also changed its character to suit. The lateral compression required for long texts and the need for smaller, portable books gave rise to a relentless rhythm of heavy, evenly spaced letters, which formed a dense texture on the page, known as textura or black letter.

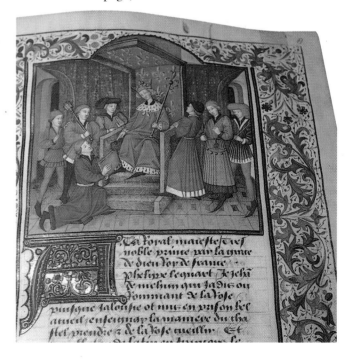

FAR RIGHT *The rounded forms of early scripts gave way to pointed arches and vigorous flourishes during the Gothic period. Illuminations became ever more enriched, as this example, from* De Consolatione Philosophiae *by Boethius (fifteenth century), shows.*

The Gothic era also saw the flowering of illumination, with monastic scriptoria at first being responsible for copying and decorating the manuscripts. Later, as the demand for books increased, professional scribes, illuminators and miniaturists took over book production and eventually formed guilds, jealously protecting their crafts.

Black letter styles persisted in Germany long after the invention of printing by movable type in the 1450s. However in Spain and Italy a more spacious form was used. 'Rotunda' was particularly suitable for the huge 'graduals' – liturgical manuscripts around which groups of singers would gather.

ITALIC REVIVAL

In around 1400, Italian humanist scholars began to search for classical texts and inscriptions. Many were recorded in Carolingian manuscripts and this script was revived as *littera antiqua*. As the style spread, it was adapted for speed to become 'humanistic cursive', and the rounded forms became elliptical. This was particularly marked in the Papal Chancery, where the scribes had to produce numerous documents very quickly. The letters sloped and were joined with ligatures, arches narrowed, and the Chancery hand, or *Cancellaresca corsive* emerged. In England this was called 'Italic' (after 'Italian'), in *Twelfth Night*, Shakespeare referring to 'the sweet Roman hand'. Italic remains the most variable and decorative of the calligraphic scripts.

Italic is extremely versatile. It may be formally written, with upright letters and space between the letters, or cursive, with a marked forward slope and ligatures. By varying the underlying ellipse of the 'O', the alphabet may be compressed or spacious, tall and light in weight or squat and heavy. Also, the long ascenders and descenders are suited to being decoratively curved and flourished.

COPY BOOKS AND COPPERPLATE

Printers in Italy introduced Italic forms to their Roman 'upper-case' and 'lower-case' alphabets. These terms derive from the compartments in which a compositor's typefaces were kept, in cases of large and small letters. The rise of printing, although taking much work away from calligraphers, was important in spreading new styles of writing.

The first writing manual or copy book to be published was *La Operina* by Vicentino Arvighi, a scribe from the Papal Chancery, in 1522. This was followed by the equally influential works of Tagliente and Palatino. In 1571 the woodcut demonstration pages were superseded by copper plates, allowing for finer lines, decorative flourishing and virtuosity.

The copy books became ever more elaborate with frames composed of flourish-drawn figures, birds and animals. However, the engraving process, skilfully mastered by such penmen as Edward Cocker, 1657, and George Bickham, 1743, had an adverse influence on lettering in Britain. The Italic hand, formed with a square-edged pen, was replaced by copperplate, written with a pointed quill or, later, a flexible metal nib. Handwriting superseded calligraphy.

THE REVIVAL OF CALLIGRAPHY

The Gothic revival of the nineteenth century fostered an interest in the arts of the Middle Ages, not least illumination. Manuscripts were slavishly copied, with the letters being drawn in outline and filled in. William Morris was the first to react against this artificial process. By experimenting with the medieval and renaissance styles, he developed a personal calligraphic hand using a broad nib, to use in his illuminated books of the 1870s. In 1890 he founded the

Kelmscott Press, which reformed the design and production of printed books. The Arts and Crafts movement, which Morris pioneered, fostered a revival in many traditional craft forms. In 1897, Edward Johnston abandoned a career in medicine to devote himself to the study of calligraphy. Encouraged to study medieval manuscripts by Morris's secretary, Sidney Cockerell, he rediscovered the tools and techniques of early scribes: chisel-edged reeds and quills, ink and vellum. W.R. Lethaby, Principal of the Central School of Arts and Crafts in London, persuaded Johnston to establish a lettering class there.

Edward Johnston based his scripts on uncial and Carolingian, but developed them in a highly personal way, remaining true to his maxims of 'Sharpness, Unity and Freedom'. In 1906, he published *Writing, Illuminating and Lettering*, which remains a classic work for all calligraphers. Among his pupils was Eric Gill, an important letter cutter and type designer. Another,

Graily Hewitt, revived medieval gilding and illuminating skills. Via the teaching of Irene Wellington, Dorothy Mahoney, Daisy Alcock and M.C. Oliver, Johnston's influence lives on in the work of many well-known calligraphers today.

At about the same time, calligraphic skills were revived in Austria and Germany by Rudolf von Larisch and Rudolf Koch, in an approach that was more intuitively based than the traditionalism of Johnston. A feature of German calligraphy has always been its close links with typographic design, for example in the work of Hermann Zapf.

Through the work of schools, colleges and societies, calligraphy is now practised by more people than ever before. From professional scribes, pushing forward the bounds to new limits of personal and artistic expression, to enthusiastic amateurs deriving pleasure from their absorbing leisure pursuit, it has a powerful and compelling appeal.

ABOVE *The revolt against the de-humanizing effect of the industrial revolution led William Morris to pioneer a revival of medieval arts and crafts towards the end of the nineteenth century. Works such as the early fourteenth-century* Metz Pontifical *(shown here) provided inspiration.*

Materials and Techniques

> 'THE NATURE AND FORM OF A LETTER IS DETERMINED BY THE NATURE AND FORM OF THE TOOL THAT MAKES IT....'
>
> *Edward Johnston*

As we have seen, the process of making letters had a great influence on the form of historical alphabets. And the basic materials of pen, ink and paper which have been used for centuries are what influences calligraphy today. A working knowledge of these essential tools will greatly help the scribe in the mastery of calligraphy.

PENS AND NIBS

The Greeks introduced a split-reed pen in the third century BC, and this produced gradations in strokes from thick to thin. Quills were in use by the sixth century AD, and continued as the main form of pen until metal nibs took over in the nineteenth century. Although quills and reeds are enjoyable to prepare and use, the processes are difficult and lengthy and metal pens are a more reliable alternative.

The square-edged pens used in calligraphy are often known as 'round hand pens'. They have a writing edge instead of a point, varying in width and, sometimes, angle. The calligraphy pen is used without pressure, and the angle at which it is held to the writing line (known as the pen angle) is usually constant and governs the distribution of thick and thin strokes. Strokes will be thick or thin depending on the direction in which the pen is moved in forming different parts of the letters.

Bronze round hand nibs are generally available in ten widths: 6, 5, 4, 3½, 3, 2½, 2, 1½, 1, 0. Smaller nibs require a lightness of touch and precision, the middle and upper

ranges being useful for general purposes. For left-handers a range of left-oblique nibs may be helpful.

The nib is inserted into a wooden or plastic pen-holder, which should feel comfortable when held in the writing position. It is best to use a pen with an ink reservoir, either detachable or forming part of the pen-holder (see box opposite). Dipping is less advisable, as the pen may be overfilled and will easily flood, producing clumsy strokes. Always wipe the pen on a rag or paper kitchen towel before and after use, and when you have finished rinse it well in clean water and dry it off.

The nib will perhaps need sharpening to grip the surface of the paper and produce a sharp stroke. For this a fine India oil stone, available at hardware stores, is required. The upper side of the nib is rubbed across the stone lightly at its tip, at an angle of around 30 degrees, to create a short, even bevel. Any metal burr clinging to the corners may be removed with a gentle, single stroke. To blunt a nib that has been over-sharpened, simply draw two or three letters at a natural angle on the surface of the stone.

Another series of pens takes off from the larger round hand sizes. Automatic and Coit pens are formed from two pieces of brass fitted into a pen-holder, bent together in a diamond shaped section. They should be filled using a brush, making sure that the whole inner width of nib is covered. The pens may be held either way round for different purposes.

Alternative pens are available with two or more teeth and can be used for experimental multi-stroke work.

Round hand pen with plastic penholder showing reservoir

Round hand pen with plastic penholder showing top of nib

Round hand pen with wooden penholder

Round hand nibs

Left oblique nibs

Reservoir

Poster pen nibs (left oblique)

Bamboo pen

A music pen has a nib which writes a stave of five parallel lines (*see the Clock face project on page 101*).

Fountain pens are available with broad edges for calligraphy. However, their disadvantages are that, unlike bronze nibs, they are inflexible; they require special ink and they also produce less sharp strokes.

A square-ended brush makes an excellent tool for more experimental work. The nylon fibred variety with widths from ½ inch (12.5mm) upwards are perfectly adequate. The hairs are flexible and pressure will affect the shape of the letters, while the fibres produce interesting results depending on the consistency of the ink or paint.

Two pencils taped or bound together with string are a useful learning tool. The double stroke produced relates to each corner of a nib and the pen angle and overlapping strokes may therefore be analysed.

Any number of other pens may be explored. Felt marker pens are useful for colourful posters. Bamboo stems may be cut with a sharp blade to form a reed-like pen. Ruling pens, cardboard and felt strips may also be experimented with.

USING INK

Ink has changed little in its formulation since its origins in Ancient Egypt and China. It is made from carbon (soot), bound with tree gum and dissolved in water. An ink known as Chinese stick is still available from specialists in small tablets. These are ground with a few drops of water into special wells until an even blackness is achieved. It is obviously easier to use prepared bottled ink, and non-waterproof Indian ink is satisfactory. The ink should always be stirred before use, and applied to the back of the nib with an old brush. Waterproof inks should be avoided as they tend to harden on the nib and clog the pen. In any case, the pen should be regularly wiped and cleaned after use.

To remove ink from paper requires care and experimentation. Thicker papers may take gentle scraping with a scalpel blade, or light rubbing with a white typewriting eraser. The roughened surface must be flattened again with careful burnishing in the direction of the grain of the paper fibres. A plastic or gilding burnisher may be used.

REGULATING INK FLOW

To store ink and regulate its flow, a slip-on reservoir is attached to the pen-holder, or a pen with a built-in reservoir is used. The tongue should just touch the nib at a short distance from its tip. The slip-on variety is clipped to the back of the nib by squeezing metal tabs around it. It should not be difficult to pull it on and off, but if too loose it will slip when the pen is filled. Ink (or paint for colour work) may be applied with an old water-colour brush to the openings on each side of the reservoir.

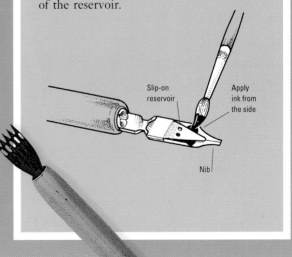

Slip-on reservoir

Apply ink from the side

Nib

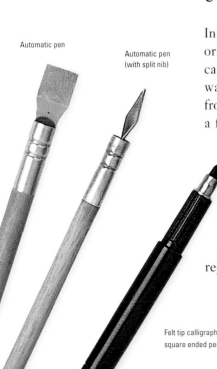

Quill

Automatic pen

Automatic pen (with split nib)

Felt tip calligraphy square ended pen

India oilstone

Old watercolour brush

Music pen

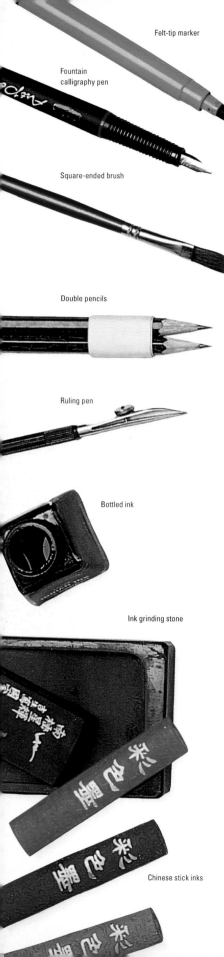

Felt-tip marker

Fountain
calligraphy pen

Square-ended brush

Double pencils

Ruling pen

Bottled ink

Ink grinding stone

Chinese stick inks

USING COLOUR

When using colour, a balance needs to be struck between the background of the paper and the ink or paint used. The letters should remain legible, through being either darker or lighter than the surface. A variant shade of the colour of the paper, or its complementary (opposite) will often be most successful. When using two or more colours either choose those which are close in shade, such as purple and pink, or create a contrasting effect using opposites, such as tawny orange and blue. It is usually best if one colour predominates and the other, perhaps a tint of the background, is knocked back.

Seek inspiration from the world around you, not only in other people's work. Observe the beauty of woodlands, flowers, sunsets and the sea, as well as successful combinations in fabrics and the other arts and crafts. Store up these ideas for use in your own projects to create a mood or make a statement.

Coloured inks are not generally suitable for calligraphy as they are thin and dry unevenly. For opaque work, designer's gouache colours are best. Available in pans or tubes, these are pigments bound in gum, which dissolve in water. A small amount of colour should be mixed in a palette or jar, with the addition of a tiny drop of zinc white for greater opacity. The ideal consistency of the fluid for calligraphy is that of single cream.

Watercolours, also available in pans and tubes, may also be used to great effect. They dry translucent, a factor which may be exploited by subtly changing mixtures. Two or three compatible colours may be added in succession to the back of a reservoir or an automatic pen. Avoid sudden colour changes between words as these will appear patchy on the page.

GILDING

Gouache substitutes for gold and other metals closely approximate to the real thing, and are available in various shades. These pigments, which are prepared in pan or tube form, should be stirred in a little water to suspend the metallic particles evenly. Apply to the nib with a brush and write in the usual way, after experimenting with the consistency to control the flow. If the nib clogs, the very tip may be dipped in water.

Illuminating gold leaf is available in books of twenty-five leaves, beaten flat into two-and-a-half-inch squares. The leaves may be loose, between fine paper, or attached to a backing like a transfer, in which form they are far easier to use. Gold leaf is applied to a sticky mordant which can be used in the pen like ink. Various liquids and sizes are commercially available, or one may be prepared from crystals of gum ammoniac. These are obtainable from specialist suppliers in small bags and resemble pieces of raw cane sugar. Begin by breaking the lumps into small particles– if necessary (and carefully) with a hammer. Place these in a clean jam jar and cover with freshly boiled water. Allow this to cool, preferably overnight, and the particles will gradually dissolve. Strain the mixture through the mesh of a pair of old tights into a clean jar. It should be whitish and have the consistency of thin cream. Stored in the refrigerator, with the lid on, the preparation keeps for several weeks.

The gum mixture flows easily from a pen but use only old brushes with it and clean them straight away in warm water. As it dries clear, it may be stained with a little red or yellow watercolour. When the letter has completely dried, breathe on it to activate the adhesiveness of the gum. (This does not need to be done the same day.) Immediately, apply a leaf of transfer gold and rub the paper with your finger until the gold has adhered. If, when you remove the sheet,

Typewriter eraser

Pencil rubber
eraser

Craft knife

Scalpel and curved blade

Watercolour pans

Watercolour tubes

Gouache tubes

Gold burnisher

Gold leaf (transfer)

MASKING FLUID

Masking fluid is a useful medium sold in jars, used for writing like an ink and drying clear on the page. Then, a colour may be applied over it, either solidly or, preferably, using a lighter technique such as sponging (see the Alphabet project on page 000), or watercolour wash. When the paint is completely dry the fluid can be carefully peeled away by rubbing gently with a soft eraser or a lump of dried fluid. The letters are revealed in the background colour of the paper, having resisted the paint. Different effects may be obtained by overlapping letters in masking fluid and solid colour. Soft papers are not recommended for use with masking fluid, as the fibres stick to the fluid and pull the surface away.

CHOICE OF PAPER

Paper was invented in China, but spread to the West in the Middle Ages, replacing parchment from the fourteenth century. It is available in a huge variety of sizes, weights, textures and colours, to suit a range of calligraphic purposes.

Layout paper For practising, a good pad of A3 layout paper is convenient. Not only is it thin and light, but it has the advantage of a certain transparency for tracing off portions of design, or to show through lines. It is easily cut with a blade or scissors and 'pasted-up' for roughs using 'cow' gum. However it will cockle if made wet and is unsuitable for using with watercolour.

Cartridge paper is adequate for experiments and also for some finished work but may become brittle with age. You will find it necessary to explore the heavier paper available in large single sheets from an art shop. Many papers come in a size of 30 x 22 inches (762 x 558mm). The most useful weights are 90 and 140 grammes per square metre (gsm).

A smooth surface is preferable for calligraphic work and painting. A slight tooth will help the pen to grip, while it will slip if the paper is too shiny. A fibrous surface will cause patchiness and spluttering, and if the paper is too absorbent the ink will bleed. The best papers to use are gelatine sized and 'hot pressed', which finishes the surface.

A thin, off-white paper with a good surface for ink or colour work is Zerkall, designed for printmaking. It is also a suitable thickness

the letter is not completely covered, the leaf may be reapplied after further breathing. Finally, after leaving the letter to dry once more for at least twenty minutes, burnish lightly with a rounded agate burnisher, but only through a piece of glassine paper. Direct burnishing will smear the size and dull the gold. With care, a slightly raised, reflective effect will be achieved. Any excess gold clinging around the letter may be removed with a soft brush.

Raised gilding on a plaster medium called 'gesso', as practised in the Middle Ages, is an art in itself for which specialist books should be consulted. Diluted PVA glue with water is a reasonable substitute for gesso but should not be used in a pen.

Khadi indian

Mingei Japanese

Ingres

Canson

Rives gris

Palette with gum ammoniac for gilding particles

Vellum

Handmade paper

Textured watercolour paper

Fabriano artistico paper

Zerkall printmaking paper

for the pages of a simple manuscript book. There are several thicker papers allowing for wetter colour work. Arches Aquarelle, Saunders Waterford and Fabriano Artistico are all recommended creamy papers, with Fabriano 5 as a white alternative.

Handmade papers, made in shallow moulds, often have the finest-quality finishes and display their origins with deckle edges and watermarks. As they can be expensive, it is advisable to experiment on sample swatches before risking everything on a large sheet.

Japanese and Indian papers have an intrinsic natural beauty in their fibrous structure, and are available in many exciting colours and with decorative features. Their difficult surfaces may be found more appropriate for experimental work, however.

Coloured papers There are many coloured papers in bright and softer shades, which add a further dimension to calligraphic work. The Ingres and Canson ranges have a slight texture caused by internal fibres and 'laid' lines which add to the subtlety of the work. Rives papers come in grey (*see the Clock face project on page 101*) and a series of other colours but have a soft, slightly furred surface. This may be exploited for effects with a brush or automatic pen, but may cause problems for fine work.

PARCHMENT AND VELLUM

Parchment and vellum have been used by scribes for over two thousand years. Parchment is, strictly speaking, the split skin of a sheep. Vellum is manufactured from calfskin or goatskin. The preparation process involves soaking in lime and scraping to remove flesh and hair. Later the skin is pegged out and dried, then scraped again by hand with a crescent-shaped blade to prepare the surface.

When it reaches the scribe, the skin may be further improved by rubbing it with pounce – a mixture of

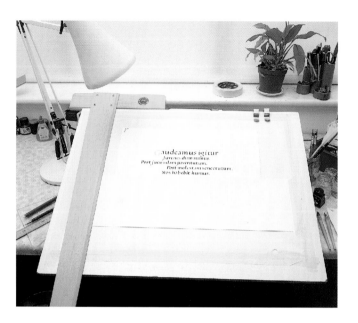

ABOVE *A well-organized work station, with everything to hand and good light, makes work efficient and even more enjoyable*

powdered pumice, cuttle-fish bone and gum sandarac – to bring up a fine, velvety nap. Both sides may be used, but usually the hair side is preferred. Vellum responds particularly well to writing with a quill. It is far more expensive than paper, but is suited for fine ceremonial work, especially when gilding is involved. The thickness of the skin allows for erasures to be made with a sharp blade or typewriting rubber, without too much difficulty.

DRAWING BOARDS

An angled drawing board helps the calligrapher to maintain an upright posture and allows the ink to flow readily from the pen. The exact angle is a matter of personal preference and may depend on the materials used – for example, at a steep angle watercolour will settle in dark drips at the base of each stroke. Somewhere around 45 degrees is generally acceptable. Adjustable drawing boards, either freestanding, or to be

stood on a table, may be purchased at some expense. A cheaper alternative is to hinge together two A2-sized pieces of plywood and create an angle by placing books or wrapped bricks between them.

One or more pieces of thick paper should be taped under loose sheets of work, to provide a flat padding and give a spring to the pen.

STARTING OUT

It is essential to be comfortable and relaxed if you are writing for any length of time.

Position the work so that you are writing at a comfortable height. To hold it down and prevent it becoming dirty, a guard sheet of folded paper may be taped just below the writing line. Left-handers can position this at an angle to facilitate natural movement.

Hold the pen at a comfortable distance from the nib, allowing your whole arm to move freely as you draw the stroke. Try not to be tense as you write – it may help to familiarize yourself with the marks made by the pen by drawing abstract patterns of pen strokes across a piece of scrap paper.

The angle of the nib relative to the writing line is slightly different for each of the three alphabets featured in this book. It is probably best to begin with the foundational alphabet, which maintains a constant pen angle of 30 degrees, producing its heaviest and finest strokes diagonally with the breadth and edge of the nib respectively. The vertical will be slightly wider than the horizontal, as experiment will show.

Drawing guide lines The space between the top and base lines determines the weight of your letters, that is, the balance between black strokes and white spaces. To control this, the x-height is established to give the height of the body of the letters and then the top and base lines are lightly ruled in as a guide. The letter height is governed by the nib width, so that it is always in proportion to the width of the pen strokes. Hold the nib vertically to draw a square of its full width. Alternate a row of such squares side by side to measure the required height of the letters. The necessary x-heights for different calligraphic styles are given later in the book. Ascenders and descenders – the 'tops' and 'tails' of the lower-case letters – rise above and below the x-height to a greater or lesser extent, depending on the writing style. Capital letters are all written to a constant height within each style – usually slightly lower than the tops of the ascenders – and rules can be drawn to mark the top and base lines.

Mark off the distance between the lines lightly with a sharp pencil down the left margin of the page. A T-square can be used for longer lines against the edge of the board, but a twelve-inch steel rule also marked in centimetres and a 60/90-degree set square are usually adequate. Slide the set square along the edge of the ruler held at a vertical angle and with a sharp pencil draw in the parallel lines.

Interlinear spacing varies enormously and makes a great difference to the effect of a page. For some purposes almost no space is acceptable (*see the* Gaudeamus *project on page 88*), but usually a proportion based on the x-height is used – often one and a half or two times as wide. Squat uncials may require less space than this, tall italics more. Small lines of writing have a denser appearance than large spacious letters, and greater spaces are required between them to compensate for this.

For practice purposes, heavy lines may be ruled with a felt pen on a piece of paper held underneath the writing sheet as a guide. If you have trouble keeping letters upright, or require a constant forward slant for italic, rule a series of sloping parallel guide lines at one-inch intervals.

Always leave margins around your work – these should be at least one inch/2.5cm at the top and sides and slightly more at the base of the page.

Letter and word spacing Typographic spacing is often close and uneven, but for calligraphy, a light and balanced texture of letters is preferred. As a rule, the space or 'counter' inside lower-case 'n' governs the distance between adjacent letters. A word such as 'minimum' will therefore appear with the uprights at regularly spaced intervals. The spaces will need to be adjusted slightly for curved and projecting letters, by placing them slightly closer together. The 'rule of three' states that the spaces each side of the central letter in any trio should be visually the same.

Between words, generally allow for the space occupied by an invisible 'o' – the space is slightly more than between the letters in a word, but somewhat less than the x-height.

LAYOUT AND DESIGN

Once the skills of letter and word spacing have been mastered, you can progress to the layout of a simple poem or short piece of prose. This may combine characters in different sizes and styles, lines of differing lengths, and, perhaps, colour or illustration.

Before starting it is important to consider the meaning of the text and a treatment which is sympathetic to the intentions of the author, as well as expressing your personal feelings. The purpose and intended setting of the work are also essential considerations. For example, should it be instantly legible (on a poster, for example), will you allow the words to speak for themselves, as in poetry, can they be interpreted and embellished, maybe within the context of a card or decorative panel?

The choice of calligraphic hand is also important – each carries a weight of historical and emotional associations. A dignified, regular script such as uncial or black letter would perhaps best suit a religious text; a light italic might be appropriate for love poetry, and free, informal capitals be fitting for humorous verses.

Once you have decided on a suitable style, begin to lay out your piece. You may already have some ideas scribbled down as 'thumbnail sketches' but it is essential to write out the whole piece to appreciate its length and pattern. In a workable pen size – although this may change later – write down the words straightforwardly, with evenly spaced lines, and observe the result. This may dictate a horizontal (landscape) or vertical (portrait) layout – try to avoid an unsatisfactory square.

Cut up the lines and rearrange them on a blank page. Be careful not to affect the meaning when splitting lines. The lines may be ranged left (lined up along the left-hand margin), in rarer cases ranged right (lined to the right), alternatively indented, or centred (placed evenly underneath each other along a vertical centre line which is easily discovered by folding each line of text in half). A centred layout may be varied by pulling out certain lines asymmetrically, so long as the overall balance is maintained, and a solid central column of words remains to form a spine.

You may also vary interlinear spacing to change the texture of the work. Some upper-case and uncial scripts require very little space between the lines, while others, such as italic, with tall ascenders and descenders, require much more. For formal scripts, allow each line to appear as a separate horizontal band, rather than knitting them together.

Layouts can also be varied by adding emphasis to certain letters, words or phrases (usually the heading) by enlarging them or using capitals. The title and author credit may also be incorporated, often restoring the balance in an awkward piece.

Colour should be considered at an early stage, as it will visually alter the appearance of the letters. A small amount of illustration may be included, using a style in keeping with the text – experiment with pen-made line drawings, stencils and rubber stamps.

RELATED FORMS

The letters in each alphabet have a family likeness based on the underlying basic forms. For example, 'O' should occupy visually the same width as 'N'. The curved backs of 'C' and 'G' relate to the opposite side of 'D'. In lower-case alphabets, the arches, whether rounded or elliptical, are particularly important and should all match each other, as well as reflecting the shape of the curved letters. Lower-case 'm' and 'n', for instance, should enclose the same space within each arch as 'h' and 'u'. It may help to see each letter as part of a group of related forms, in shape, width and angle.

For the Roman alphabet, related upper-case letters form the following groups:

Full width, straight-sided letters
H L N T U

Letters based on the circle
C D G O Q

Vertically narrower letters
B P R S E F I J K

Angular letters
A M V W X Y Z

For lower-case letters, related forms are:

Curved letters
ceo

Straight and curved letters
adlpqb

Diagonal letters
kvwx

Tailed letters
fj

Arched letters
mh

PASTE-UP

Now you are ready to glue the lines down in the required arrangement to use as a guide. Rubber solution ('cow' gum) is best for this, as it enables the lines to be easily removed and replaced in different positions. However, it is not suitable for long-lasting work as it eventually discolours and is not permanent. After sticking, remove all the excess glue with a soft eraser or a lump of dried gum.

Make a ruling guide from your layout by drawing the writing lines on to tracing paper at spaced intervals. Also mark the beginning and end of each line of text. Draw over the back of your tracing with a soft pencil, then transfer it to the final paper or redraw the lines on to the paper directly.

BEGINNING WORK

Fold the paste-up with the crease just underneath the first line of text. Lightly tape this above your writing line with masking tape and accurately copy the words. This is the best way to ensure correct spacing, as tension will often produce tighter letters at the beginning of a piece. Continue with this method, folding the rough each time, throughout the text, always taking care not to smudge the letters while the ink or paint is still wet.

Keep your first layouts simple and clear. As you develop, and gain confidence more complex ideas and combinations can be explored. Use historical and contemporary works for inspiration, and observe the worlds of art, media and nature for ideas.

Pen angles, letter proportions and letter forms

The pen is normally held at a constant angle to the writing line, known as the pen angle, which differs for each of the three alphabet styles described in this book. Letter proportions are governed by nib widths.

Notes for left-handed calligraphers

Left-handedness is regarded as less of an obstacle in learning calligraphy these days than it used to be. Though it undoubtedly does present extra problems, these can readily be overcome with the right information and perseverance.

It is difficult to differentiate between problems encountered specifically through being left-handed and those encountered by most calligraphy beginners. Whether left- or right-handed, the usual beginner's difficulties are: learning control of the pen (developing technical skill); understanding and accurate rendering of related letter forms (producing a unified alphabet); achieving accurate letter spacing, and developing a writing rhythm – the latter improving as all the other skills fall into place. Acquiring technical skill is admittedly rendered more difficult by being left-handed, because all the left-handed writing positions have disadvantages, but these can be overcome.

LEFT-HANDED
WRITING POSITIONS

There are three main left-handed writing positions and pen holds, each with advantages and disadvantages. The choice of writing position and pen hold will be influenced by a number of factors, including the position and pen hold already used for everyday handwriting, the advice of right-handed calligraphy teachers with whom the student may come in contact, advice on left-handedness from calligraphy books and articles, advice from other left-handed calligraphers – whether fellow students or teachers, and finally, of course, personal preference as a result of experience. Position 1 is the underarm position with the writing

line horizontal, as for right-handers. Position 2 is the 'natural' left-handed position, which necessitates the writing line running vertically. Position 3 is the overarm or 'hook' position, with the writing line horizontal. Left-handed beginners may wish to try all three positions before deciding, or adopt the recommended underarm position straight away.

POSITION 1

The underarm left-handed writing position (position 1) is in the long run the best one to adopt, but it entails turning the left hand right back against the wrist, especially when writing scripts requiring steep pen angles (such as italic, where the nib edge of the pen needs to be held at 40/45 degrees to the horizontal writing line), and this position creates strain on the hand and arm. However, with practice the position becomes less forced, and writing flows more readily.

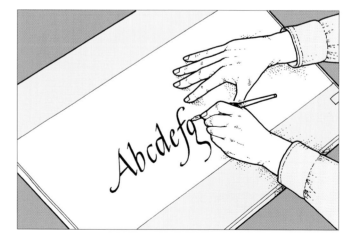

POSITION 1 *Underarm position and pen hold, with horizontal writing line.*

This is the position adopted by the majority of left-handed calligraphers, its advantages greatly outweighing its disadvantages, even though it is not a natural position for the left-hander.

In this position, the nib angles, pen-holder direction, stroke directions and pull and push strokes are the same as for right-handers. This is an overwhelming advantage, especially when being instructed by a right-handed teacher and teaching yourself from books.

The main disadvantage is that, initially, it may be difficult to obtain the steeper pen angles needed for scripts such as italic (40-45 degrees) as the hand has to be turned right back to the left against the wrist. This may feel forced and awkward to begin with, but the wrist becomes more flexible with use in this position. In turning the hand back the elbow is brought right into the side of the body, which somewhat restricts arm movement. This can gradually be overcome, by keeping the whole arm as loose as possible. In any case, this tends to happen naturally as one becomes more familiar with the scripts and consequently one can write in a more relaxed way.

There are a number of suggestions to help the left-hander successfully cope with the difficulty of turning the hand back to write in the underarm position.

• Begin with scripts which do not require very steep pen angles. These will be easier, enabling some skill in handling the pen to be built up before the steeper, more difficult pen angles are tried (for italic – 40-45 degrees – and for the Roman capitals A M N V W X Y – 45 degrees or more. Foundational hand, requiring a pen angle of 30 degrees for most letters, is a good initial script, as are flat pen uncial, with horizontal, 0-degree pen angle, and angled pen uncial, with a slight pen angle not exceeding 25 degrees.

• Have a wide writing board for all work – at least two and a half feet (76 centimetres), and a guard sheet of folded paper the total width of the board, attached with tape at both sides of the board. This wide board will enable writing in progress to be moved to the left, as necessary, once or twice per line of writing. In order to move the writing sheet to the left in this way it will obviously need to be narrower than the guard sheet. This keeps the writing in the best position for left-handers – slightly to the left of the body all the time, with the hand and arm positioned as shown in the diagram on page 22 for easier hand and arm movement (allowing more easily obtained steep pen angles).

• Write slightly to the left of your body to avoid increased tension in the hand and arm and greater difficulty with steeper pen angles. But note that writing too far to the left will give an inaccurate perspective on the work.

• For very large work you may need a larger plywood drawing board that can be placed on the desk easel or hinged to a smaller base board and propped up at the required board angle on books or tins. If the paper is larger than the board you may have to dispense with the guard sheet altogether, so that the sheet can be moved to the left as you write. The wide writing board also gives a surface on which

POSITION 2 *The 'natural' left-handed position with the writing line turned to the vertical position.*

the non-writing hand and forearm can rest, taking the pressure off the writing hand – this is also helpful for right-handed calligraphers.

POSITION 2

In position 2 the 'natural' left-handed writing position is maintained, with the paper turned at right angles so that the lettering is done from top to bottom. Some left-handed calligraphers write well in this way because it is an easy position for the left hand, being a mirror image of the right-hander's position. However, the vertical writing line does not suit everyone, and it is largely a matter of personal choice whether this option suits you or not.

This position has the advantage of giving free hand and arm movement, and is generally less difficult in the early learning stages than the underarm position. The hand movements themselves are predominantly left to right and right to left – lateral, rather than predominantly vertical as in the other writing positions, left- and right-handed, but the pull and push strokes are the same as for right-handers and underarm (position one) left-handers.

The disadvantages are that the vertical writing line presents an unusual perspective on the writing, making it more difficult to judge the slope of some scripts, and that the predominantly lateral movements of the writing strokes are very different from the writing movements in everyday handwriting and those of edged-pen calligraphy with the other writing positions. It would also be difficult to be instructed by a teacher using a different writing position, whether left- or right-handed, as the whole movement and direction of strokes is so entirely different.

Some people produce excellent calligraphy using position two, but the disavdantages of a vertical writing line are considerable and it is probably best to leave this option as a last resort rather than a first choice.

POSITION 3

The third position is the overarm or 'hook' position. As a comfortable position which enables free-flow of writing, this is fine for everyday handwriting with writing tools such as ball-point pens, pointed felt tip pens and pointed fountain pens, and it may also suit the use of edged fountain pens because their nibs are narrow and do not offer much resistance when pushed. However, this writing position has severe disadvantages when it comes to using the full range of broad-edged calligraphy nibs.

Its advantages are that it allows easier hand and arm movement than underarm position 1, as the hand is not constricted in any way, and that the steeper angles – particularly the 40/45-degree pen angle for italic – are easily obtained.

The main disadvantage of this position is that the nib comes in from the top left direction with the nib edge pointing down – the reverse of the right-handed and underarm left-handed positions. This results in all the pull strokes of the right-hander (and underarm left-hander) becoming push strokes against the front of the nib, and push strokes becoming pull strokes (see

POSITION 3 *The 'hook' position, although it is often used by left-handers for ordinary handwriting, can make calligraphy difficult.*

diagram, *right*). This is a reversal of the push and pull strokes of the scripts as they evolved historically. There is more resistance between nib and writing surface in a push stroke than with a pull stroke (and the majority of strokes in most scripts are pull strokes), and the natural writing rhythm is obviously going to be different, and less fluid.

A further disadvantage with using the 'hook' position is that it makes it difficult to avoid the hand moving across the lettering as the line proceeds, so that smudging of the ink is likely, particularly with fast-flowing writing and with large-scale letters (with automatic pens, for example).

Also, as we have seen, the downstrokes become push, rather than pull, strokes, and the ink tends to flow less readily on push strokes. This tends to lessen the flow of writing. (In most scripts the push strokes are usually thin upstrokes which do not offer much resistance against the nib.)

Finally, in this position the writing hand obscures what has just been written.

Some left-handed calligraphers get good results using the 'hook' position (position 3), but all things considered, the underarm position (position 1) is best, enabling the left-hander to write all the scripts with the same stroke direction, pen position and flow as right-handers. (This is also an enormous advantage when being taught by a right-handed teacher, as the actual pen-holder direction and all pen movements are exactly the same.)

Left-handers already using the 'hook' position for everyday handwriting or calligraphy will have developed a certain writing facility. If they are considering a change to underarm position one, it might be a good idea to practise with the new position until it feels as natural as the old position, but to use the old position for any important finished work, until the results are as good with the new way as the old and the final complete changeover can be made.

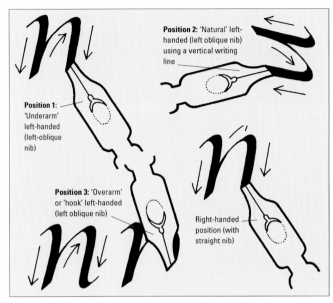

The left-hander's writing positions compared to that of a right-hander. Left-oblique nibs are useful in all left-hand positions.

CONCLUSION

In conclusion, although the underarm position, position 1, is advisable, there will not be one writing position that suits all left-handers and it is useful to try them all. Once the left-hander has found one to suit and other setting-up details – such as the wide board and guard sheet, left-oblique nibs and writing slightly to the left of the body – are adopted, then writing success is largely a matter of concentrating on good letter shapes, spacing, rhythm and design. With regular practice the hand position will become increasingly easier and if problems persist a demonstration from a left-handed calligrapher is a great help, as a lot of difficulties are dispelled once you can see someone else writing in the same position as your own.

Take heart if you are left-handed and have encountered or foreseen problems: with practice, the whole creative spectrum of calligraphy is open as much to you as to anyone else.

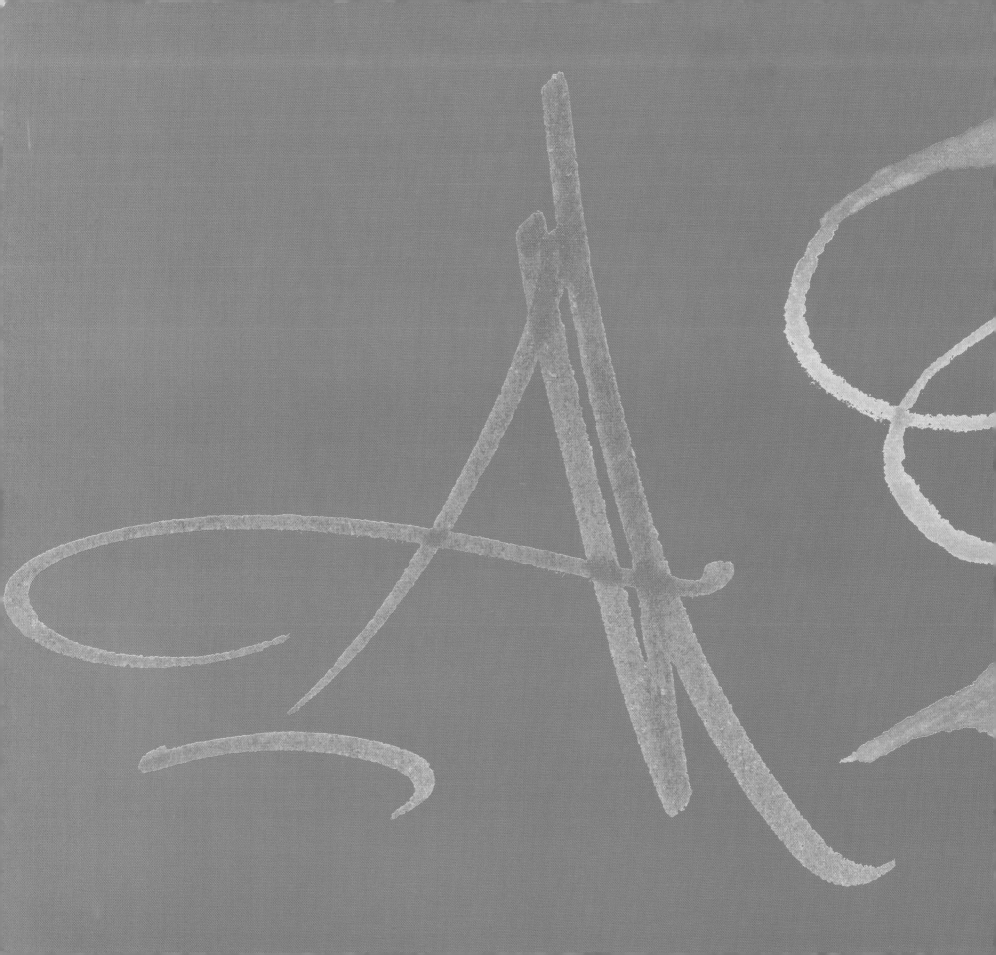

A – Z
STEP BY STEP

In calligraphy, the pen is kept at a constant angle to the writing line, except for a few manipulations of the pen in forming parts of certain letters. The height of the capital letters and the x-height of the lower-case letters are governed by the width of the pen used, as is the extent of the ascenders and descenders (top and bottom 'tails'). Each style of writing has its own basic pen angle and nib-width rules, as shown below.

FOUNDATIONAL SCRIPT

Pen angle – almost constant 30 degrees

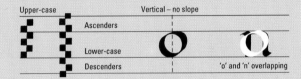

Upper-case Vertical – no slope

Ascenders

Lower-case

Descenders 'o' and 'n' overlapping

ITALIC SCRIPT

Pen angle – about 40 degrees with a few manipulations

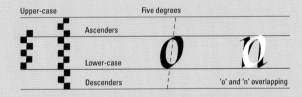

Upper-case Five degrees

Ascenders

Lower-case

Descenders 'o' and 'n' overlapping

UNCIAL SCRIPT

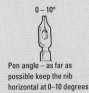

Pen angle – as far as possible keep the nib horizontal at 0–10 degrees

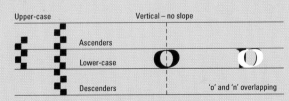

Upper-case Vertical – no slope

Ascenders

Lower-case

Descenders 'o' and 'n' overlapping

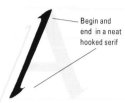

'A' is not only the first letter of the alphabet, but, along with 'B', also gives its name to the twenty-six letters it leads – from the Greek 'Alpha-Beta'.

The origin of 'A' is to be found in the Egyptian hieroglyph for an eagle. This was simplified by scribes, and adapted by the Phoenicians, who straightened out its curves. Finally the Greeks placed the letter upright and formed 'Alpha', the same as is used today.

The strong symmetrical form of the Roman 'A' suggests a stable pyramid or the gable of house. However, in 1529 it was likened by Geoffroy Tory to a man standing with his legs apart, and a crossbar for modesty!

In the lower-case letter, the fully rounded shape grew out of the uncial form, in which a bowl replaces the left-hand stroke and crossbar.

FOUNDATIONAL – UPPER-CASE

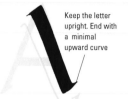
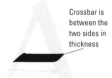
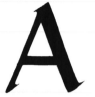

Begin and end in a neat hooked serif

Keep the letter upright. End with a minimal upward curve

Crossbar is between the two sides in thickness

1 *Hold the pen at a steepened angle to make a thin straight line.*

2 *Thick stroke, to match the first, with pen at a 30° angle.*

3 *Place the crossbar just below halfway down the letter.*

Completed foundational upper-case 'A'.

ITALIC – UPPER-CASE

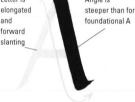
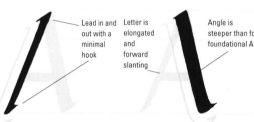
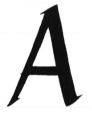

Lead in and out with a minimal hook

Letter is elongated and forward slanting

Angle is steeper than for foundational A

1 *Steepen the pen angle and form a straight thin stroke.*

2 *Draw in the thick stroke, curving slightly at the base.*

3 *Add the horizontal crossbar just below halfway down.*

Completed italic upper-case 'A'.

UNCIAL – UPPER-CASE

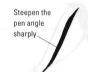
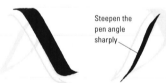
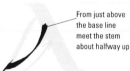
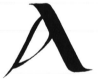

Steepen the pen angle sharply

From just above the base line meet the stem about halfway up

1 *A shallow diagonal which has a minimal lead-in and out.*

2 *A fine stroke mirroring the angle of the stem.*

3 *Twist the pen and form the bowl with the corner of the nib.*

Completed uncial upper-case 'A'.

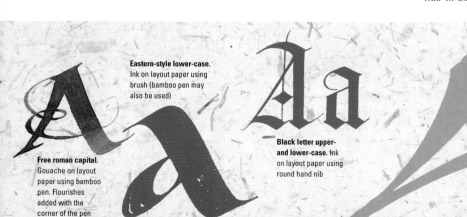

Free roman capital. Gouache on layout paper using bamboo pen. Flourishes added with the corner of the pen

Eastern-style lower-case. Ink on layout paper using brush (bamboo pen may also be used)

Black letter upper- and lower-case. Ink on layout paper using round hand nib

Freely written capital. Ink on layout paper using brush

Informal alphabet. Ink on layout paper using a brush

Copperplate upper-case. Ink on layout paper using flexible pointed steel nib

Roman form versal. written with two stro of narrow round han pen. Ink on layout pa

LOWER-CASE

Begin just below the top line

Blend smoothly, not crookedly into the vertical side

Finish with a tightly rounded base curve

Position about halfway down the stem

Meet the stem at the thinnest part of the curve

1 *Draw a rounded arch with a constant 30° pen angle.*

2 *Draw a straight, fine stroke, curving, back round to form the bowl.*

Completed foundational lower-case 'a'.

LOWER-CASE

Return upwards with the left corner of the nib – as if to complete an ellipse

The thin stroke of the bowl meets the stem around halfway up

Begin at the end of the apex curve

1 *A curved wedge is pulled down from the top line.*

2 *The apex is a short, flattened curve clinging to the top line.*

3 *Draw a straight downstroke with a minimal hooked serif.*

Completed italic lower-case 'a'.

LOWER-CASE

Carry round a little with the corner of the nib

Stop when the stroke widens to its full extent

Curve when the side connects with the base of the bowl

1 *Draw a semicircular stroke from the top to the base line.*

2 *Add a flattened curve to form the top of the letter.*

3 *Leading in from top right, draw the vertical side.*

Completed uncial lower-case 'a'.

FOR LEFT-HANDERS

Left-oblique broad-edged nibs are recommended for left-handed beginners, and usually make the pen angle easier to maintain. Once you have got used to them you will probably want to continue with them, although some left-handers can write perfectly well with straight nibs. Angled nibs greatly facilitate steeper pen angles because the hand has to be turned back against the wrist less than with a straight-cut nib. (The 'Rexel' nibs are particularly recommended.) It is useful to be able to demonstrate with the straight nibs used by right-handers if you want to teach calligraphy to right-handed people.

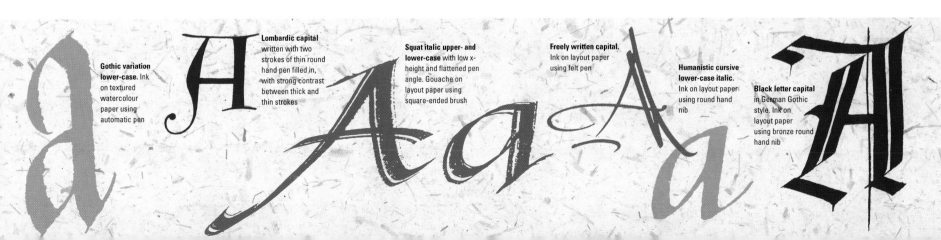

Gothic variation lower-case. Ink on textured watercolour paper using automatic pen

Lombardic capital written with two strokes of thin round hand pen filled in, with strong contrast between thick and thin strokes

Squat italic upper- and lower-case with low x-height and flattened pen angle. Gouache on layout paper using square-ended brush

Freely written capital. Ink on layout paper using felt pen

Humanistic cursive lower-case italic. Ink on layout paper using round hand nib

Black letter capital in German Gothic style. Ink on layout paper using bronze round hand nib

Bb

'B' began life as a crane in Egyptian pictograms, simplified into the shape of a tent. Its Hebrew and Phoenician name 'Beth' means 'house', possibly with two individual chambers, one each for men and women. The Greek letter 'Beta' was adapted in turn by the Romans, who curved its triangular lobes to form the character we know today.

Victor Hugo, author of *The Hunchback of Notre Dame*, appropriately likened 'B' to 'a hump – the back on the back', in 1829.

The lower-case form ascends above the line and has only one lobe. The origin of ascenders and descenders may have been to split words into syllables and thus aid reading.

FOUNDATIONAL – UPPER-CASE

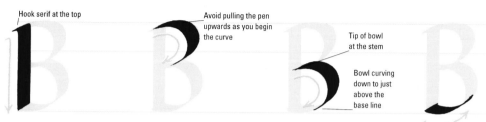

Hook serif at the top

Avoid pulling the pen upwards as you begin the curve

Tip of bowl at the stem

Bowl curving down to just above the base line

1 *The vertical stem of the letter ends just on the base line.*

2 *From stem serif, the top bowl curves round like part of a circle.*

3 *In the same way, draw a larger bowl at the base.*

4 *A shallow curve smoothly connecting stem and bowl.*

ITALIC – UPPER-CASE

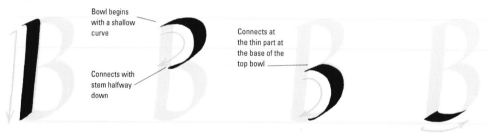

Bowl begins with a shallow curve

Connects with stem halfway down

Connects at the thin part at the base of the top bowl

1 *A straight stem, with a slight hook serif, ends as it touches the base line.*

2 *Top bowl connects with a fine line drawn down into the stem.*

3 *Draw a slightly larger curve of the same shape.*

4 *Connect to the vertical at the base with a shallow curve.*

UNCIAL – UPPER-CASE

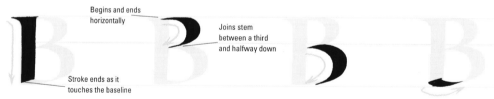

Begins and ends horizontally

Joins stem between a third and halfway down

Stroke ends as it touches the baseline

1 *Make a vertical stem stroke with a wedged serif at the top.*

2 *Draw a semicircular bowl from the top, to join the stem.*

3 *A larger semicircular bowl drawn from the thin part of the top bowl.*

4 *Finish with a shallow curve connecting the stem and the bowl.*

Humanistic cursive lower-case italic. Ink on layout paper using round hand nib

Freely written capital. Ink on layout paper using pointed steel nib

Squat Italic lower-case. Drawn with a brush

Free Roman capital. Gouache on layout paper using bamboo pen. Flourishes added with the corner of the pen

Italic swash-style upper-case. Ink on layout paper using round hand pen

Italic swash capital. Ink on layout paper using round hand nib

LOWER-CASE

Completed foundational upper-case 'B'.

Make a smooth, shallow upward curve without creating a corner

1 *Vertical stroke with slight hook serif, curving towards the base.*

Allow the stroke to widen from the moment it begins

A slight overlap at the base avoids a weak joint

2 *Form a bowl from the top line without curving upwards.*

Completed foundational lower-case 'b'.

LOWER-CASE

Completed italic upper-case 'B'.

Emerge about halfway up the line

1 *Straight line and minimal hook serif as for upper-case 'B'.*

Curve resembles right-hand side of an italic 'o' connected at base with a shallow curve

2 *From the base, draw the pen up to form an elliptical curve.*

Completed italic lower-case 'b'.

LOWER-CASE

Begins with a wedged serif

Completed uncial upper-case 'B'.

1 *The vertical stroke begins above the line and curves near the base.*

Ends with a flattened curve

Connect with the stem by a slight overlap at the base.

2 *A fine line pulls a semicircular bowl out from the stem.*

Completed uncial lower-case 'b'.

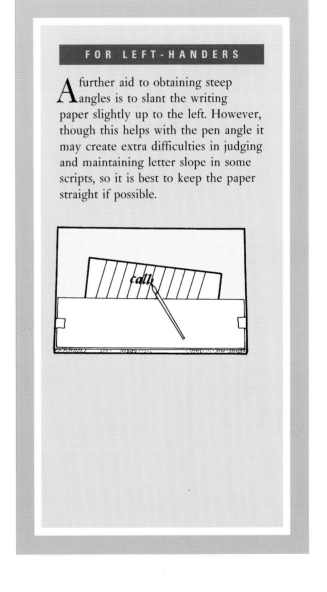

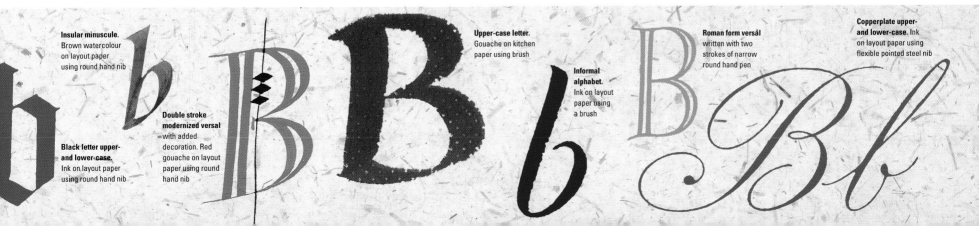

Black letter upper- and lower-case. Ink on layout paper using round hand nib

Insular minuscule. Brown watercolour on layout paper using round hand nib

Double stroke modernized versal with added decoration. Red gouache on layout paper using round hand nib

Upper-case letter. Gouache on kitchen paper using brush

Informal alphabet. Ink on layout paper using a brush

Roman form versål written with two strokes of narrow round hand pen

Copperplate upper- and lower-case. Ink on layout paper using flexible pointed steel nib

The Egyptian hieroglyphic origin of 'C' is a throne. This was simplified to look more like a camel, and it was named 'Gimel' by the Hebrews and Phoenicians, who wrote it rather like a number seven. The Greeks reversed the letter they named 'Gamma', and it was rounded by the Romans, who gave it a hard 'k' sound. They also used it to stand for the hundreds in their system of numerals.

Although it is a much-used letter, all the various sounds that are made by 'C' can be represented by other letters of the alphabet. Both upper- and lower-case forms are the same, and Victor Hugo remarked on its crescent-like form.

FOUNDATIONAL – UPPER-CASE

Do not to pull inwards too early or the letter will slope backwards

1 *The curve of the letter is a left-sided semicircle.*

2 *Add a flattened apex curve, hooking the end downwards.*

Completed foundational upper-case 'C'.

ITALIC – UPPER-CASE

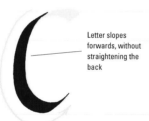

Letter slopes forwards, without straightening the back

1 *The body of the letter is the left side of an ellipse.*

2 *Complete in a flattened apex curve, hooked at the end.*

Completed italic upper-case 'C'.

UNCIAL – UPPER-CASE

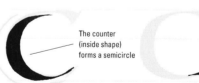

The counter (inside shape) forms a semicircle

1 *A curved stroke is drawn down from the top to the base line.*

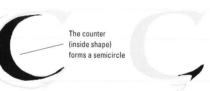

2 *Twist the pen from horizontal to 30° to form the serif.*

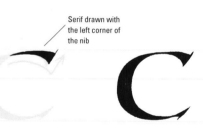

Serif drawn with the left corner of the nib

3 *The flattened apex curve is finished with an upward serif.*

Completed uncial upper-case 'C'.

Informal alphabet. Ink on layout paper using a brush

Eastern-style upper-case. Ink on layout paper using brush (bamboo pen may also be used)

Copperplate upper- and lower-case. Ink on layout paper using flexible pointed steel nib

Black letter upper- and lower-case. Ink on layout paper using round hand nib

Roman form versal written with two strokes of narrow round hand pen. Ink on layout paper

Insular minuscule. Brown watercolour on layout paper using round hand nib

Gothic variation upper-case. Ink on textured watercolour paper using automatic pen

LOWER-CASE

1 *The main body is a semicircle, just like the upper-case 'C'.*

2 *Complete with a flattened curving wedge at the apex.*

Completed foundational lower-case 'c'.

LOWER-CASE

1 *The left side of an ellipse, a shorter version of upper-case 'C'.*

2 *Complete the letter with a small, short, hooked wedge.*

Completed italic lower-case 'c'.

LOWER-CASE

End in a small serif drawn with the corner of the nib

1 *Draw a curving stroke with a slightly drawn-out base.*

2 *With pen at about 30° make apex curve. End in inward hook.*

Completed uncial lower-case 'c'.

FOR LEFT-HANDERS

If you have to tilt the paper you may need to draw pencil slope lines on the writing sheet at one-inch or one-and-a-half inch (2.5 or 3.8 cm) intervals to keep a constant letter slope – for italic, for example. With layout or other thin paper a slope grid – rules in black ball-point pen or pointed felt tip – can be slipped underneath the writing sheet to aid slope, which saves ruling slope lines on every sheet.

Ruled guide lines for an even slope

Free roman capital. Gouache on layout paper using bamboo pen. Flourishes added with the corner of the pen

Italic upper- and lower-case with steepened pen angle and wide x-height. Ink on layout paper using round hand pen

Uncial lower-case double-stroke written in ink with an automatic pen

Modernized versal written with two strokes of narrow round hand pen filled in. Gouache on calico

Lombardic capital written with two strokes of thin round hand pen filled in, with strong contrast between thick and thin strokes

Upper-case letter. Gouache on hand-made Khadi paper using toothbrush

Informal alphabet. Ink on layout paper using a brush

Dd

In Egyptian hieroglyphics, the symbol corresponding to 'D' was a hand. The Phoenicians converted this into a triangle with a short tail called 'Daleth', meaning 'door' – in their case a curtain hung before a tent. For the Greeks the triangular 'Delta' could be written at various angles. The Romans stood it on its side and rounded the bowl. 'D' stood for the number five hundred.

Geoffroy Tory likened the letter to a Roman theatre, with a curved auditorium and a straight stage side.

The lower-case form of 'D' sprang out of the uncial shape, with its diagonal ascender above a rounded letter.

FOUNDATIONAL – UPPER-CASE

Do not curve upwards from the stem

1 *A vertical straight side, ending as it touches the line.*

2 *Form a semicircular bowl with a slightly flattened top.*

3 *Connect the stem and bowl with a shallow base curve.*

Completed foundational upper-case 'D'.

ITALIC – UPPER-CASE

1 *Start with a straight side which ends just where it meets the line.*

2 *The bowl is the right side of an ellipse, starting at the serif.*

3 *A flattened curve connects the base of the stem and the bowl.*

Completed italic upper-case 'D'.

UNCIAL – UPPER-CASE

Begin above the line with a wedge serif

1 *Begin with a semi-circular curve, as for uncial upper-case 'C'.*

2 *Diagonal which curves at the top line to complete the half circle.*

Completed uncial upper-case 'D'.

Informal alphabet. Ink on layout paper using a brush

Flourished Italic lower-case. Ink on Zerkall paper using round hand nib

Double stroke modernized versal with added decoration. Red gouache on layout paper using round hand nib

Modern versal based on runic letters. Gouache on Calico

Italic variation with low x-height and lateral expansion. Ink on layout paper with round hand pen

Black letter upper- and lower-case. Ink on layout paper using round hand nib

Copperplate upper- and lower-case. Ink on layout paper using flexible pointed steel nib

LOWER-CASE

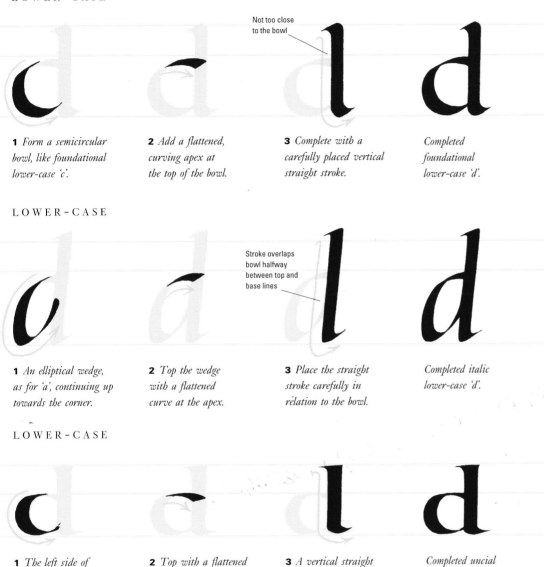

Not too close
to the bowl

1 *Form a semicircular bowl, like foundational lower-case 'c'.*

2 *Add a flattened, curving apex at the top of the bowl.*

3 *Complete with a carefully placed vertical straight stroke.*

Completed foundational lower-case 'd'.

LOWER-CASE

Stroke overlaps
bowl halfway
between top and
base lines

1 *An elliptical wedge, as for 'a', continuing up towards the corner.*

2 *Top the wedge with a flattened curve at the apex.*

3 *Place the straight stroke carefully in relation to the bowl.*

Completed italic lower-case 'd'.

LOWER-CASE

1 *The left side of a circle, curling upwards at the base.*

2 *Top with a flattened wedge curving down from the apex.*

3 *A vertical straight side with a shallow curve at the very base.*

Completed uncial lower-case 'd'.

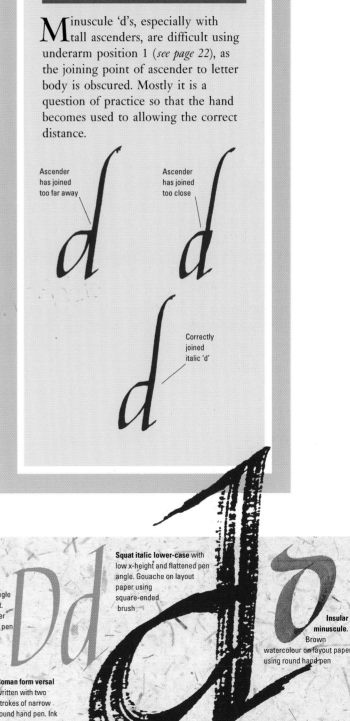

FOR LEFT-HANDERS

Minuscule 'd's, especially with tall ascenders, are difficult using underarm position 1 (*see page 22*), as the joining point of ascender to letter body is obscured. Mostly it is a question of practice so that the hand becomes used to allowing the correct distance.

Ascender has joined too far away

Ascender has joined too close

Correctly joined italic 'd'

Gothic variation upper-case. Ink on textured watercolour paper using automatic pen

Free roman capital. Gouache on layout paper using bamboo pen. Flourishes added with the corner of the pen

Freely written capital. Ink on layout paper using brush

Roman form versal written with two strokes of narrow round hand pen. Ink on layout paper

Italic upper- and lower-case with steepened pen angle and wide x-height. Ink on layout paper using round hand pen

Squat italic lower-case with low x-height and flattened pen angle. Gouache on layout paper using square-ended brush

Insular minuscule. Brown watercolour on layout paper using round hand pen

Ee

Appropriately, 'E' is the most popular letter in European usage. It derives from the Egyptian symbol for breathing – a squared spiral form. The scribes wrote this as a crossbar with three pendent lines, which the Phoenicians adopted as 'He' – a window, and placed on its side. The Greeks reversed the letter and called it 'Epsilon' – for the first time using it as a vowel.

The greek form of 'E' has an angular or curved back, and with the upper two bars joined up, the lower-case letter arose. The Roman character has a decidedly upright back and this prompted Victor Hugo to envisage 'the whole of architecture in a single letter – the foundations, the pillar, the console and the architrave'.

FOUNDATIONAL – UPPER-CASE

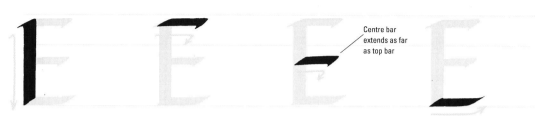

1 *A vertical straight stroke ending as it touches base line.*

2 *The top bar is joined to the vertical and hooked at the very end.*

3 *The centre bar is added halfway down the stem.*

Centre bar extends as far as top bar

4 *The base bar is added, finishing with upwardly curving tip.*

ITALIC – UPPER-CASE

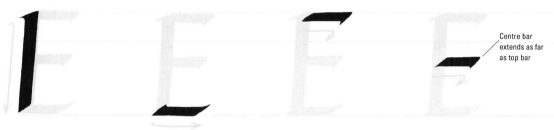

1 *The straight stem stroke ends where it touches the base line.*

2 *Form the base bar, curving up slightly at the tip.*

3 *The top bar has a hooked serif at the very end.*

Centre bar extends as far as top bar

4 *Place the centre bar just above halfway down the first stroke.*

UNCIAL – UPPER-CASE

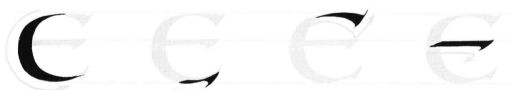

1 *Semicircular left-hand curve, extended slightly at the base.*

2 *Twist the pen to a 30° angle to form the triangular serif.*

3 *Apex curve ending in a serif drawn with left corner of the nib.*

4 *Complete with a crossbar drawn with a pen angle of 30°.*

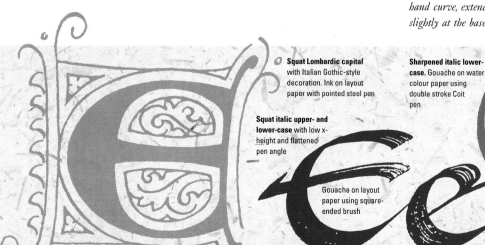

Squat Lombardic capital with Italian Gothic-style decoration. Ink on layout paper with pointed steel pen

Squat italic upper- and lower-case with low x-height and flattened pen angle

Gouache on layout paper using square-ended brush

Sharpened italic lower-case. Gouache on water-colour paper using double stroke Coit pen

Lombardic capital written with two strokes of thin round hand pen filled in, with strong contrast between thick and thin strokes based on uncial shape

Modernized versal. Blue and green watercolour on Zerkall paper using two strokes of round hand pen

Uncial lower-case double-stroke written in ink with an automatic pen

Versal upper-case written with two strokes of narrow round hand pen. Ink on layout paper. Roman letter form

LOWER-CASE

Bowl joins the body at one third to halfway down

Extend slightly upwards at the base

Completed foundational upper-case 'E'.

1 *Make a semicircular curve as for foundational 'c'.*

2 *Add the curving but slightly angular bowl at the top.*

Completed foundational lower-case 'e'.

LOWER-CASE

Meet the stem just above halfway

Completed italic upper-case 'E'.

1 *For the left side, form an ellipse, like lower-case 'c' in shape.*

2 *Add the elliptical bowl, curving inwards and upwards.*

Completed italic lower-case 'e'.

LOWER-CASE

Ends in a narrow triangle drawn with corner of the nib

Line begins one third of the way down

Completed uncial upper-case 'E'.

1 *A semicircular left-hand curve is drawn out at the base.*

2 *The bowl curves round as if partly completing the circle.*

3 *A fine shallow upward curve meets base of bowl curve.*

Completed uncial lower-case 'e'.

FOR LEFT-HANDERS

Exercises that encourage loosening up of the hand and arm when writing using position 1 (*see page 22*) include writing large letters with a pencil or felt tip – pointed or edged, on large sheets of layout paper or wallpaper lining paper. This will encourage fluidity and arm movement you can then try writing large with automatic and Coit pens, which are also helpful. The pencil and felt tips glide more easily over the paper than metal edged pens, especially when you are in the early stages of learning.

Copperplate upper-case. Ink on layout paper using flexible pointed steel nib

Modernized versal written with two strokes of narrow round hand pen filled in. Gouache on calico. Based on runic inscriptions

Free roman capital. Gouache on layout paper using bamboo pen. Flourishes added with the corner of the pen

Insular minuscule. Brown watercolour on layout paper using round hand nib

Italic variation with low x-height and lateral expansion. Ink on layout paper with round hand pen

Black letter upper- and lower-case. Ink on layout paper using round hand nib

Sharpened italic lower-case. Gouache on watercolour paper using automatic pen

Informal alphabet. Ink on layout paper using a brush

Informal capital with 'manipulated' serifs. Gouache on watercolour paper with automatic pen

Along with several other letters, 'F' originates in the Egyptian horned asp hieroglyph, 'Cerastes'. The two bars retain the horns of the snake, and the tail represents its body.

The Phoenicians altered this to a Y shape named 'Wau', meaning 'a peg'. Greek scribes adopted the Y form as 'Digamma' but eventually abandoned the letter. 'F' was finally introduced by the Romans with a new, softer sound. However, Victor Hugo darkly likened its shape to that of a gibbet.

Lower-case 'f' has similarities to its parent form although the crossbar is lengthened, and the curved top and extended tail have inspired many variations in the different scripts.

FOUNDATIONAL — UPPER-CASE

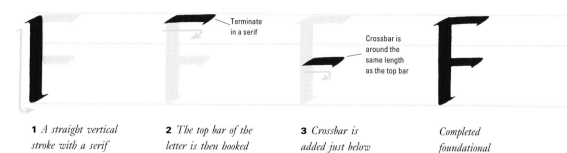

Terminate in a serif

Crossbar is around the same length as the top bar

1 *A straight vertical stroke with a serif at each end.*

2 *The top bar of the letter is then hooked at the very end.*

3 *Crossbar is added just below halfway down.*

Completed foundational upper-case 'F'.

ITALIC — UPPER-CASE

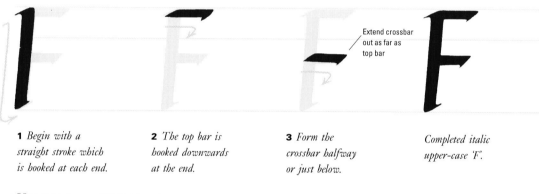

Extend crossbar out as far as top bar

1 *Begin with a straight stroke which is hooked at each end.*

2 *The top bar is hooked downwards at the end.*

3 *Form the crossbar halfway or just below.*

Completed italic upper-case 'F'.

UNCIAL — UPPER-CASE

Stem ends with a backward pointing tail-off

Arch finished with upward movement of corner of the nib

Crossbar along the top of the base line

1 *Make a vertical straight stem ending below the base line.*

2 *Flattened apex arch is made with pen angle of 30°.*

3 *The extended crossbar ends in a triangular serif.*

Completed uncial upper-case 'F'.

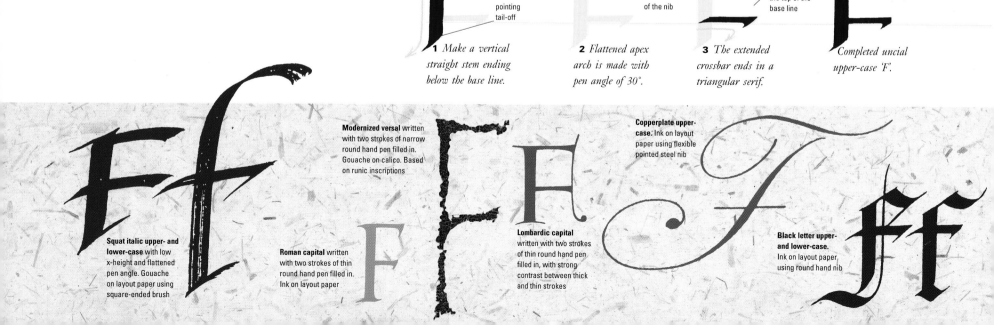

Squat italic upper- and lower-case with low x-height and flattened pen angle. Gouache on layout paper using square-ended brush

Modernized versal written with two strokes of narrow round hand pen filled in. Gouache on calico. Based on runic inscriptions

Roman capital written with two strokes of thin round hand pen filled in. Ink on layout paper

Lombardic capital written with two strokes of thin round hand pen filled in, with strong contrast between thick and thin strokes

Copperplate upper-case. Ink on layout paper using flexible pointed steel nib

Black letter upper- and lower-case. Ink on layout paper using round hand nib

LOWER-CASE

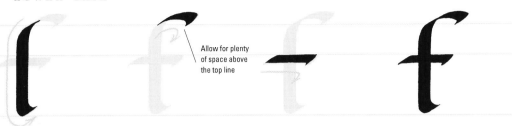

Allow for plenty of space above the top line

1 *Fine lead-in curve, not angular, flows into a straight vertical.*

2 *Apex curve, connected smoothly to the stem and hooked at the tip.*

3 *Place the crossbar, projecting each side of the stem.*

Completed foundational lower-case 'f'.

LOWER-CASE

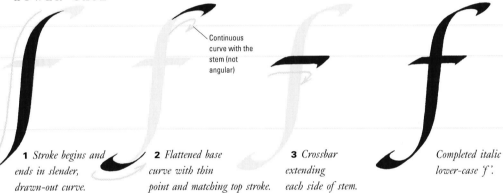

Continuous curve with the stem (not angular)

1 *Stroke begins and ends in slender, drawn-out curve.*

2 *Flattened base curve with thin point and matching top stroke.*

3 *Crossbar extending each side of stem.*

Completed italic lower-case 'f'.

LOWER-CASE

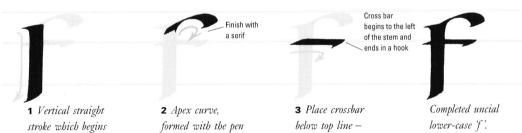

Finish with a serif

Cross bar begins to the left of the stem and ends in a hook

1 *Vertical straight stroke which begins just above the top line.*

2 *Apex curve, formed with the pen at an angle of 30°.*

3 *Place crossbar below top line – pen angle 30°.*

Completed uncial lower-case 'f'.

FOR LEFT-HANDERS

Ragged stroke edges occur wherever the contact with the paper has been broken, and are a common problem for left-handed calligraphers, especially with the somewhat awkward underarm writing position. Some may find it difficult, initially, to keep the whole edge of the nib in contact with the paper all the time. To prevent this, press down more firmly on the side of the nib where the ragged edges occur – usually the left side.

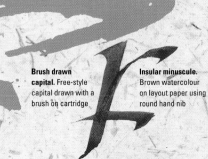

Humanistic cursive lower-case italic. Ink on layout paper using round hand nib

Squat Lombardic capital with Italian Gothic-style decoration. Ink on layout paper with pointed steel pen

Informal alphabet. Ink on layout paper using a brush.

Versal upper-case written with two strokes of narrow round hand pen. Ink on layout paper

Brush drawn capital. Free-style capital drawn with a brush on cartridge

Insular minuscule. Brown watercolour on layout paper using round hand nib

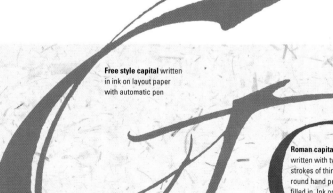

'G' arose out of the Latin 'C', a rounded form of the Greek letter 'Gamma'. Until the third century BC the Romans used 'C' to represent both sounds, but modified it into a new form for the sake of convenience. At first they added just an upward stroke at the base, and this later acquired first a hook and then a crossbar.

'G' retains both hard and soft sounds; Victor Hugo called it 'a French horn'.

The lower-case form came about via the uncial capital with its extended tail. This was compressed vertically until the curve closed up altogether. In the Gothic era a straight-sided tail was devised, relating better to the black letter alphabet.

FOUNDATIONAL – UPPER-CASE

The extent is the same as that of the apex ending

1 *Form the lower left side of circle as for the letter 'C'.*

2 *Add a flattened apex curve which is hooked in at the tip.*

3 *Finish with hooked straight stroke halfway down the letter.*

Completed foundational upper-case 'G'.

ITALIC – UPPER-CASE

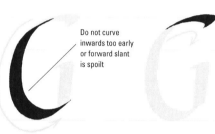

Do not curve inwards too early or forward slant is spoilt

Stroke begins half-way down the letter

1 *Form the left side of an ellipse as for italic upper-case 'C'.*

2 *Add the flattened apex curve at the top of the first stroke.*

3 *Straight stroke down and connecting with curve at the base.*

Completed italic upper-case 'G'.

UNCIAL – UPPER-CASE

Curve ends in upward lift of corner of nib

1 *Begin with a semicircular curve, as for the letter 'C'.*

2 *Fine upward curve is pulled down to tail off at the left.*

3 *The final apex curve is formed with a pen angle of 30°.*

Completed uncial upper-case 'G'.

Free style capital written in ink on layout paper with automatic pen

Roman capital written with two strokes of thin round hand pen filled in. Ink on layout paper

Black letter lower-case. Ink on layout paper using round hand nib

Roman capital with highly contrasting thick and thin strokes. Ink on layout paper

Copperplate upper- and lower-case. Ink on layout paper using flexible pointed steel nib

Squat italic upper- and lower-case with low x-height and flattened pen angle. Gouache on layout paper using square ended brush

LOWER-CASE

Circle touches top line
and ends above base

Extend
diagonally in
a straight line

When crossing
base line,
curve back to
begin flattened
ellipse of tail

1 *Form the lower left side of circle.*

2 *Complete the circle, extending below line.*

3 *Complete tail with hooked, flattened curve.*

4 *Add short horizontal stroke below top line.*

Completed foundational lower-case 'g'.

LOWER-CASE

Slender,
curving
tail off

Tail curve has
slight hook

1 *An elliptical bowl relating to 'a' and 'd'.*

2 *Flattened curve finishes off the apex.*

3 *Straight stroke, narrowing to tail-off.*

4 *Flattened tail curve joined to stem.*

Completed italic lower-case 'g'.

LOWER-CASE

Curve ends
just above
base line

Stroke extends
just below
base line

Ellipse is just
wider than
letter body

A short curve
connects to
top corner of
the body

1 *Flattened semicircle from top line.*

2 *Begin to complete the circle but extend stroke.*

3 *Draw right side of flattened ellipse.*

4 *Add a curved balancing wedge.*

Completed uncial lower-case 'g'.

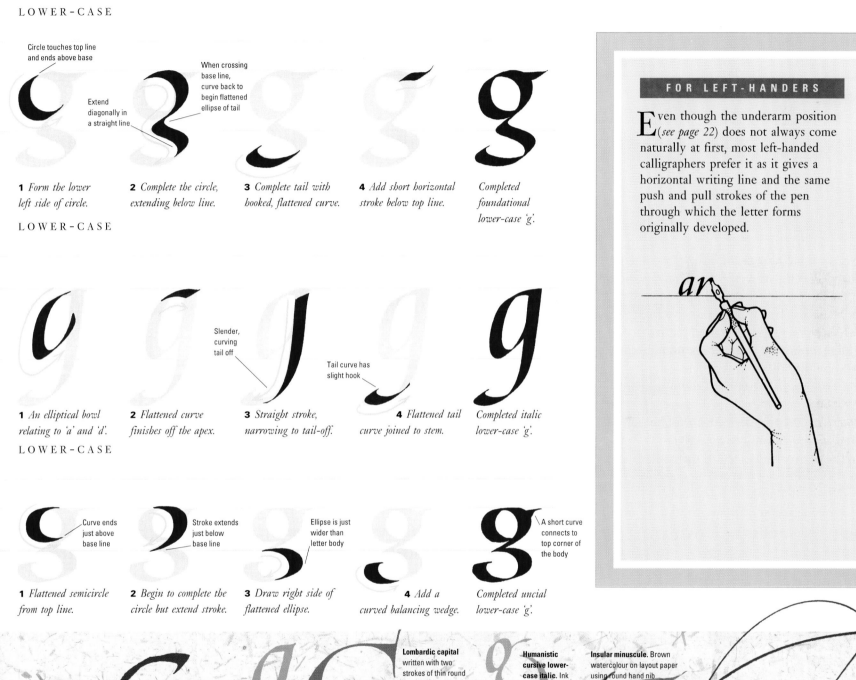

FOR LEFT-HANDERS

Even though the underarm position (*see page 22*) does not always come naturally at first, most left-handed calligraphers prefer it as it gives a horizontal writing line and the same push and pull strokes of the pen through which the letter forms originally developed.

Italic upper-case with steepened pen angle and wide x-height. Ink on layout paper using round hand pen

Italic lower-case. Ink on Zerkall paper using round hand metal nibs and automatic pen

Lombardic capital written with two strokes of thin round hand pen filled in, with strong contrast between thick and thin strokes

Free roman capital. Gouache on layout paper using bamboo pen. Flourishes added with the corner of the pen

Humanistic cursive lower-case italic. Ink on layout paper using round hand nib

Insular minuscule. Brown watercolour on layout paper using round hand nib

Informal alphabet. Ink on layout paper using a brush

Free italic with pointed steel nib. Ink on layout paper

Free versal runic style

Hh

The Egyptian hieroglyph for a sieve, modified into a ladder, is the origin of 'H'. The Phoenician letter 'Cheth' meaning 'knee' comprised two uprights connected by three transverse bars. The Greeks retained only the central bar to form 'Meta'. It became a breathing sound, soon disappearing from Roman usage. As a result, 'H' is found little in the Latin-based languages – Italian, Spanish and French. In English, 'H' often remains silent in Latin-derived words, but is pronounced in those of a Saxon origin.

Geoffroy Tory likened 'H' to the body of a two-storied house, and Victor Hugo also saw the facade of a building, with two towers.

By extending the left-hand vertical, and reducing that on the right, lower case 'h' was formed.

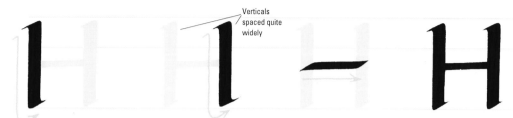

FOUNDATIONAL – UPPER-CASE

Verticals spaced quite widely

1 Draw a straight vertical stem, which begins and ends in a hook.

2 Add another, exactly matching, vertical stroke to the right.

3 A horizontal crossbar is placed halfway down the letter.

Completed foundational upper-case 'H'.

ITALIC – UPPER-CASE

1 A straight slanting stroke, which is hooked at each end.

2 Identical straight stroke, placed fairly close to the first.

3 Finish with horizontal cross bar, halfway down the letter.

Completed italic upper-case 'H'.

UNCIAL – UPPER-CASE

Serif above the line

Ends in short flat foot

Curve tails off as it returns to the base line

1 Vertical straight stroke beginning with a wedge serif.

2 Add a full arching curve, beginning inside the stem.

Completed uncial upper-case 'H'.

Copperplate lower-case.
Ink on layout paper using flexible pointed steel nib

Steepened italic lower-case

Lombardic capital
written with two strokes of thin round hand pen filled in, with strong contrast between thick and thin strokes. Uncial form

Free roman capital.
Gouache on layout paper using bamboo pen. Flourishes added with the corner of the pen

Insular minuscule.
Brown watercolour on layout paper using round hand nib

Italic swash capital
Ink on layout paper using round hand nib

LOWER-CASE

Stroke is allowed to widen as soon as it leaves stem, without pulling pen upwards

1 *The straight ascender stroke is made with an arched serif.*

2 *A smoothly rounded arch, with a widening stroke.*

Completed foundational lower-case 'h'.

LOWER-CASE

Stroke leaves the stem halfway between top and base lines

1 *Straight slanting ascender ends at base line, without a serif.*

2 *Elliptical arched stroke, straightening as soon as it turns over.*

Completed italic lower-case 'h'.

LOWER-CASE

Begin inside the stem

Ascender ends with a flat foot.

1 *Vertical straight ascender, with a wedge serif.*

2 *Pull the pen out in a wide arch tailing off as it returns to the base line.*

Completed uncial lower-case 'h'.

Black letter upper- and lower-case. Ink on layout paper using round hand nib

Informal alphabet. Ink on layout paper using a brush

Sharpened italic lower-case. Gouache on watercolour paper using automatic pen

Roman capital Ink on layout paper using round hand nib

Squat italic upper-case with low x-height and flattened pen angle. Gouache on layout paper using square-ended brush

Eastern-style lower-case. Ink on layout paper using brush

Ii

'I' is the simplest letter form and in English represents the personal pronoun.

The serifs are already present in the two parallel lines of the Egyptian hieroglyph. With a vertical joining stroke the Phoenician and Hebrew letter 'Yod' was formed. This was used to refer to the most insignificant things, and survives in the term 'a jot'. The Greeks used 'Iota' in the same way, at first depicted using a zig-zag.

In Latin, 'I' was used as both a consonant with a Y sound, and a vowel. It also represented units of one in the numeral system.

Geoffroy Tory conjured a Romantic image of Jupiter (whose name begins with 'I' in Latin), suspending a golden chain from heaven, 'well proportioned in length and breadth'.

The dot of 'i' dates from the Middle Ages, when it became necessary to distinguish it from other letters in the closely spaced uprights of black letter.

FOUNDATIONAL — UPPER-CASE

1 *A vertical straight stroke which is hooked at each end.*

Completed foundational upper-case 'I'.

ITALIC — UPPER-CASE

1 *A slanting straight stroke, hooked at both ends.*

Completed italic upper-case 'I'.

UNCIAL — UPPER-CASE

1 *A vertical straight stroke beginning with a wedge serif.*

Completed uncial upper-case 'I'.

Black letter upper- and lower-case. Ink on layout paper using round hand nib

Italic upper- and lower-case with steepened pen angle and wide x-height. Ink on layout paper using round hand pen

Italic swash capital. Ink on layout paper using round hand nib

Roman capital Ink on layout paper using round hand nib

Italic lower-case. Ink on Zerkall paper using round hand metal nibs and automatic pen

Lombardic capital written with two strokes of thin round hand pen filled in

Humanistic cursive lower-case italic. Ink on layout paper using round hand nib

Squat italic upper- and lower-case with low x-height and flattened pen angle. Gouache on layout paper using square-ended brush

LOWER-CASE

1 *Vertical stroke with an arch serif at both ends.*

2 *Comma-shaped dot, pulled back to the left at a 30° angle.*

Completed foundational lower-case 'i'.

LOWER-CASE

1 *A slanting straight stroke hooked at both ends.*

2 *Comma-shaped dot, pulled back to the left at a 30° angle.*

Completed italic lower-case 'i'.

LOWER-CASE

1 *A vertical straight stroke beginning with a wedge serif.*

Dot is pulled back from horizontal with left corner of nib

2 *Finish with a small comma-shaped dot.*

Completed uncial lower-case 'i'.

FOR LEFT-HANDERS

For the left-hander the forefinger has to be straight or slightly concave up to the knuckle, when using the underarm writing position, to exert a sufficiently firm pressure on the pen-holder to hold the nib at the required angle. A convex forefinger would be too weak to hold the pen firmly enough. As for right-handers, the forefinger and thumb meet on top of the pen-holder, which rests on the first joint of the forefinger (*see the diagram on page 47*).

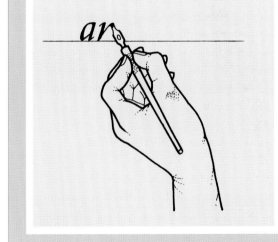

Informal alphabet. Ink on layout paper using a brush

Free roman capital. Gouache on layout paper using bamboo pen. Flourishes added with the corner of the pen

Roman lower-case. Ink on cartridge paper

Italic variation with low, expanded x-height. Ink on layout paper with round hand pen

Informaral alphabet. Ink on layout paper using a brush

Copperplate upper- and lower-case. Ink on layout paper using flexible pointed steel nib

Insular minuscule. Ink on layout paper using brush (bamboo pen may also be used)

Versal upper-case written with two strokes of narrow round hand pen. Ink on layout paper. May be filled in as required. Roman letter form

Modernized versal written with two strokes of narrow round hand pen filled in. Gouache on calico. Based on runic inscriptions

Jj

'J' grew out of an alternative form of 'I'. Until the thirteenth century, 'I' stood for both the vowel and the J consonant sound. Scribes began to extend the tail when 'I' appeared at the beginning of a word. The dot is also borrowed from 'i', but the T-like crossbar is a practice derived from printed forms and is not generally used in calligraphy.

'J' is still not found in Italian, and is silent in Spanish. German speakers have retained the original Y sound, while the soft G sound comes from Old French.

Victor Hugo, writing in 1839, referred to 'J' as 'a ploughshare, or a horn of plenty'.

FOUNDATIONAL – UPPER-CASE

1 *A straight vertical stroke pulled into curve towards the base line.*

2 *Curved wedge-shaped tail, overlapping thin part of the stem.*

Completed foundational upper-case 'J'.

ITALIC – UPPER-CASE

Tail formed below base line

1 *Slanted straight stroke pulled into curved tail.*

2 *Wedge-shaped curve joining smoothly at thin end of stem.*

Completed italic upper-case 'J'.

UNCIAL – UPPER-CASE

Pull out with left corner of nib

1 *A vertical straight stroke with wedge serif pulled out at the base line.*

2 *A comma-shaped tail is added with a pen angle of 30°.*

Completed uncial upper-case 'J'.

Squat italic upper- and lower-case with low x-height and flattened pen angle. Gouache on layout paper using square ended brush

Upper-case uncial embossed in Canson textured paper

Roman capital written with two strokes of thin round hand pen filled in. Ink on layout paper

Lombardic capital written with two strokes of thin round hand pen filled in, with strong contrast between thick and thin strokes

Free roman capital written with two strokes of thin round hand pen filled in. Ink on layout paper

Black letter upper- and lower-case. Ink on layout paper using round hand nib

LOWER-CASE

Stroke begins with arched serif

1 *Vertical stroke extends into a fine curve below base line.*

2 *Curving wedge-shaped tail, joining smoothly at end of stem.*

3 *Comma shaped dot*

Completed foundational lower-case 'j'.

LOWER-CASE

Curve formed below base line

Overlap should be smooth

1 *Slanted straight stroke narrowing to a fine curve.*

2 *Wedge-shaped tail curve, overlapping at thin end of stem.*

3 *Comma-shaped dot, pulled back at 30°.*

Completed italic lower-case 'j'.

LOWER-CASE

Pulled out serif at base line with left corner of nib

1 *Vertical straight stroke beginning with wedge serif.*

2 *Comma-shaped tail is added at a pen angle of 30°.*

3 *Comma-shaped dot is pulled back from a near-horizontal angle.*

Completed uncial lower-case 'j'.

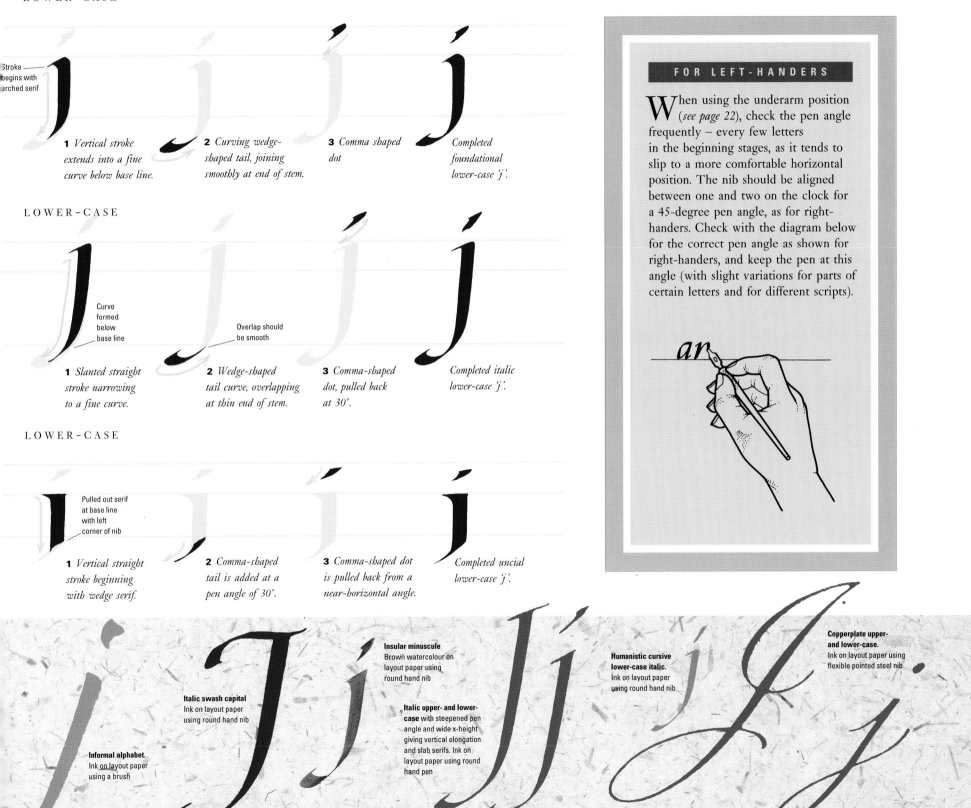

FOR LEFT-HANDERS

When using the underarm position (*see page 22*), check the pen angle frequently – every few letters in the beginning stages, as it tends to slip to a more comfortable horizontal position. The nib should be aligned between one and two on the clock for a 45-degree pen angle, as for right-handers. Check with the diagram below for the correct pen angle as shown for right-handers, and keep the pen at this angle (with slight variations for parts of certain letters and for different scripts).

Insular minuscule
Brown watercolour on layout paper using round hand nib

Italic swash capital
Ink on layout paper using round hand nib

Italic upper- and lower-case with steepened pen angle and wide x-height giving vertical elongation and slab serifs. Ink on layout paper using round hand pen

Humanistic cursive lower-case italic.
Ink on layout paper using round hand nib

Copperplate upper- and lower-case.
Ink on layout paper using flexible pointed steel nib

Informal alphabet.
Ink on layout paper using a brush

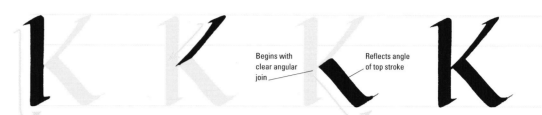

FOUNDATIONAL — UPPER-CASE

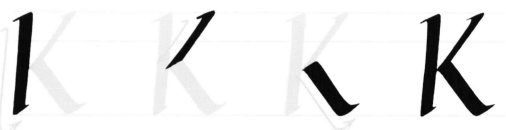

Begins with clear angular join

Reflects angle of top stroke

1 *The vertical straight stroke is hooked at both ends.*

2 *At full height, diagonal pulled back to meet stem halfway down.*

3 *Straight tail begins where both strokes meet the stem.*

Completed foundational upper-case 'K'.

ITALIC — UPPER-CASE

1 *Slanting straight stroke hooked at each end.*

2 *Fine diagonal at full letter height, touching stem halfway down.*

3 *Straight tail mirroring upper angle, turning up at the very end.*

Completed italic upper-case 'K'.

UNCIAL — UPPER-CASE

Stroke meets stem halfway between top and base lines

Tail leaves stem with clear, angular join

1 *Vertical straight stem beginning with wedge above top line.*

2 *Thin diagonal stroke with triangular serif at top line.*

3 *Straight tail stroke mirrors angle of upper stroke.*

Completed uncial upper-case 'K'.

The Egyptian hieroglyph for a boat became K when the scribes and Phoenicians modified it into a reversed form called 'Kaph', or 'palm of the hand'. The Greeks turned it round and named it 'Kappa'. In Rome the hard sounding 'C' was used and 'K' was not adopted. It is still not found in Latin languages. The English had also used 'C' in Anglo-Saxon times, but later introduced 'K' to represent the hard sound, often at the end of a word.

The shape of 'K' is similar in both upper- and lower-case forms, although sometimes a bowl replaces the upper diagonal. Its geometrical character was recognized by Victor Hugo who wrote, 'K is the angle of reflection, equal to the angle of incidence'.

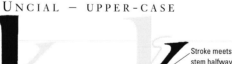

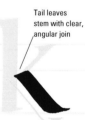

Double stroke versal upper-case with round hand nib and decoration added with pointed steel pen. Red gouache on layout paper

Modernized versal. Blue and green watercolour on Zerkall paper using single stroke round hand pen

Italic upper- and lower-case with steepened pen angle and wide x-height giving vertical elongation and slab serifs. Ink on layout paper using round hand pen

Uncial variation upper-case. Ink on layout paper using round hand round hand pen

Copperplate lower-case. Ink on layout paper using flexible pointed steel nib

Roman capital written with two strokes of thin round hand pen filled in. Ink on layout paper

Free roman capital. Gouache on layout paper using bamboo pen. Flourishes added with the corner of the pen

Informal alphabet. Ink on layout paper using a brush

LOWER-CASE

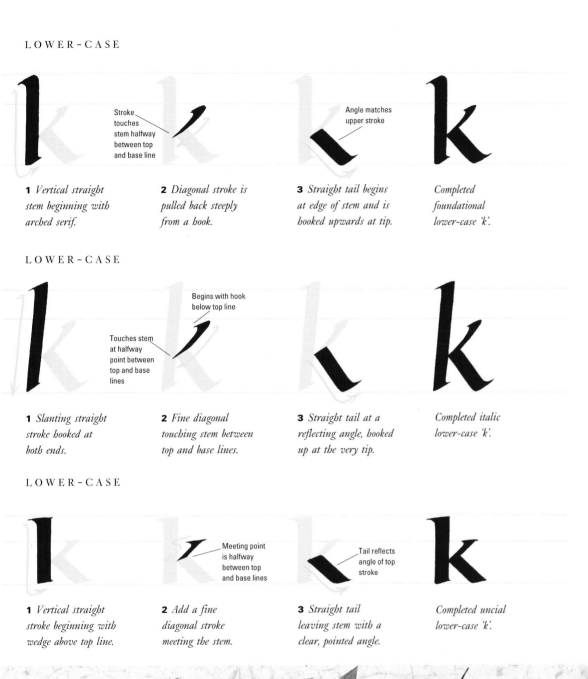

1 *Vertical straight stem beginning with arched serif.*

Stroke touches stem halfway between top and base line

2 *Diagonal stroke is pulled back steeply from a hook.*

Angle matches upper stroke

3 *Straight tail begins at edge of stem and is hooked upwards at tip.*

Completed foundational lower-case 'k'.

LOWER-CASE

1 *Slanting straight stroke hooked at both ends.*

Begins with hook below top line

Touches stem at halfway point between top and base lines

2 *Fine diagonal touching stem between top and base lines.*

3 *Straight tail at a reflecting angle, hooked up at the very tip.*

Completed italic lower-case 'k'.

LOWER-CASE

1 *Vertical straight stroke beginning with wedge above top line.*

Meeting point is halfway between top and base lines

2 *Add a fine diagonal stroke meeting the stem.*

Tail reflects angle of top stroke

3 *Straight tail leaving stem with a clear, pointed angle.*

Completed uncial lower-case 'k'.

FOR LEFT-HANDERS

When using the underarm position (*see page 22*) try to avoid awkward and uncomfortable variations, with the arm leaning either too far to the left or to the right. The arm can lean slightly to the left in the position shown, for a comfortable and efficient writing position.

Leaning slightly to the left with the arm reduces strain on the wrist

Roman form versal written with two strokes of narrow round hand pen. Ink on layout paper

Humanistic cursive lower-case italic. Ink on layout paper using round hand pen

Lombardic capital written with two strokes of thin round hand pen filled in, with strong contrast between thick and thin strokes

Insular minuscule. Brown watercolour on layout paper using round hand pen

Black letter upper- and lower-case. Ink on layout paper using round hand nib

Sharpened italic lower-case. Gouache on watercolour paper using automatic pen

Squat italic upper- and lower-case with low x-height and flattened pen angle. Gouache on layout paper using square-ended brush

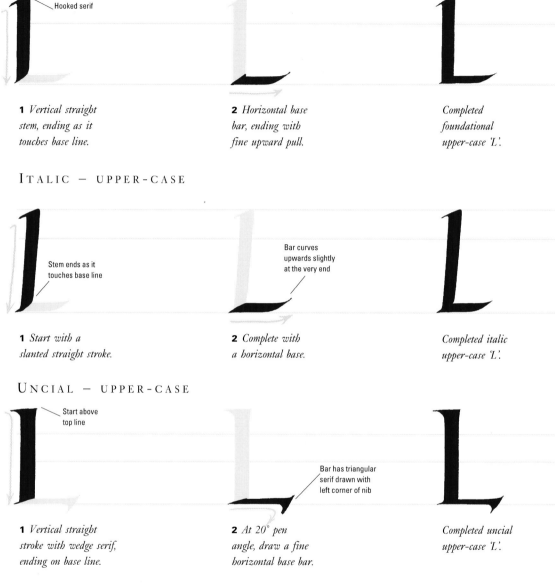

FOUNDATIONAL – UPPER-CASE

Hooked serif

1 *Vertical straight stem, ending as it touches base line.*

2 *Horizontal base bar, ending with fine upward pull.*

Completed foundational upper-case 'L'.

ITALIC – UPPER-CASE

Stem ends as it touches base line

Bar curves upwards slightly at the very end

1 *Start with a slanted straight stroke.*

2 *Complete with a horizontal base.*

Completed italic upper-case 'L'.

UNCIAL – UPPER-CASE

Start above top line

Bar has triangular serif drawn with left corner of nib

1 *Vertical straight stroke with wedge serif, ending on base line.*

2 *At 20° pen angle, draw a fine horizontal base bar.*

Completed uncial upper-case 'L'.

'L' has its origins in the scripted version of the Egyptian hieroglyph for a lioness. The Phoenicians named it 'Lamed' – an ox-goad. As a chevron, the Greeks used 'Lambda', but the Romans straightened 'L' to form the current letter. They also used it to represent the number fifty.

'A human body and its shadow' was Geoffroy Tory's simile for 'L'; Victor Hugo seeing only the leg and its foot.

The lower-case form, once again deriving from uncial forms, smoothes out the right angle and curtails the foot to form an arch. Other variations of 'L', usually in italic hands, slope the upper stem forwards and extend the foot into a flourished tail.

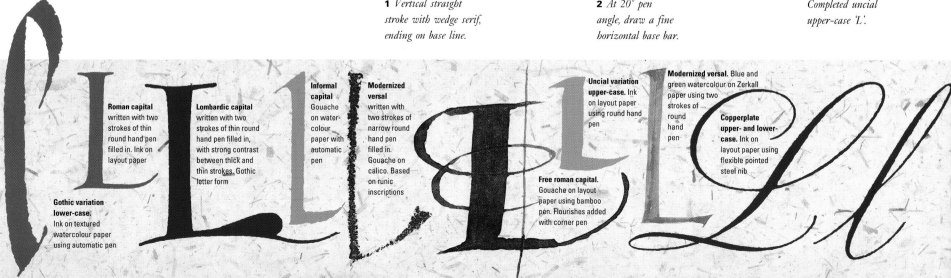

Roman capital written with two strokes of thin round hand pen filled in. Ink on layout paper

Gothic variation lower-case. Ink on textured watercolour paper using automatic pen

Lombardic capital written with two strokes of thin round hand pen filled in, with strong contrast between thick and thin strokes. Gothic letter form

Informal capital Gouache on watercolour paper with automatic pen

Modernized versal written with two strokes of narrow round hand pen filled in. Gouache on calico. Based on runic inscriptions

Free roman capital. Gouache on layout paper using bamboo pen. Flourishes added with corner pen

Uncial variation upper-case. Ink on layout paper using round hand pen

Modernized versal. Blue and green watercolour on Zerkall paper using two strokes of round hand pen

Copperplate upper- and lower-case. Ink on layout paper using flexible pointed steel nib

LOWER-CASE

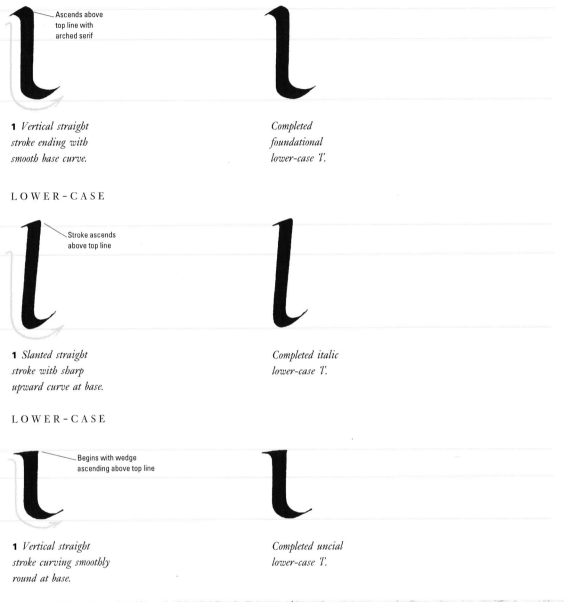

Ascends above
top line with
arched serif

1 *Vertical straight
stroke ending with
smooth base curve.*

*Completed
foundational
lower-case 'l'.*

LOWER-CASE

Stroke ascends
above top line

1 *Slanted straight
stroke with sharp
upward curve at base.*

*Completed italic
lower-case 'l'.*

LOWER-CASE

Begins with wedge
ascending above top line

1 *Vertical straight
stroke curving smoothly
round at base.*

*Completed uncial
lower-case 'l'.*

FOR LEFT-HANDERS

The left hander starts the writing line with the hand position shown on page 49 and the arm gradually becomes more vertical (*as here*) as the writing progresses.

Any variations between this and the position shown on page 49 will be found to be satisfactory.

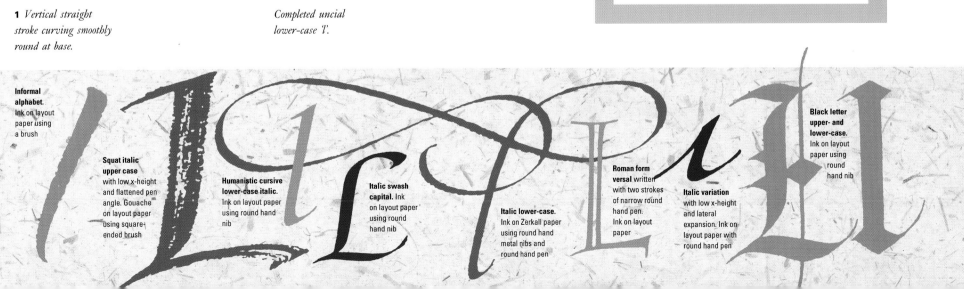

Informal alphabet. Ink on layout paper using a brush

Squat italic upper case with low x-height and flattened pen angle. Gouache on layout paper using square-ended brush

Humanistic cursive lower-case italic. Ink on layout paper using round hand nib

Italic swash capital. Ink on layout paper using round hand nib

Italic lower-case. Ink on Zerkall paper using round hand metal nibs and round hand pen

Roman form versal written with two strokes of narrow round hand pen. Ink on layout paper

Italic variation with low x-height and lateral expansion. Ink on layout paper with round hand pen

Black letter upper- and lower-case. Ink on layout paper using round hand nib

The features of the Egyptian origins of 'M' – the ears and beak of a horned owl, are still visible. A simplified, angular form was created by the Phoenicians. The Greek letter 'Mu' was adopted unchanged by the Romans, its pronunciation deriving directly from ancient usage. They also used it to represent the thousands in their numbering system.

The width and symmetry of 'M' were exploited by the Romans. The strength of the letter should always be maintained by extending its central point right down to the base line.

Geoffroy Tory's suggestion that 'M' is 'like some men, who are so stout that their belt is longer than their body is tall', is less than flattering. Victor Hugo saw a mountain, whose peaks are rounded in the lower-case form. Each arch occupies the space of one letter of ordinary width.

FOUNDATIONAL – UPPER-CASE

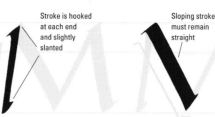

Stroke is hooked at each end and slightly slanted

Sloping stroke must remain straight

The central strokes meet at a sharp point and form a V

Stroke ends in an upward hook

1 *Narrow stroke made with pen angle steepened to around 60°.*

2 *At a pen angle of 45°, add a sloping central stroke.*

3 *Next stroke, with pen at 60°, mirrors the angle of the second.*

4 *The fourth stroke mirrors the first stroke – at a 30° pen angle.*

ITALIC – UPPER-CASE

Stroke begins and ends in a hook

Stroke is formed with a pen angle of 60° and balances the previous one

1 *Slightly slanted narrow stroke made with a nib angle of 60°.*

2 *At a pen angle of 45°, make a shallow diagonal.*

3 *Next stroke meets the second to form a narrow V-shaped point.*

4 *At a pen angle of 30°, the fourth stroke mirrors the first.*

UNCIAL – UPPER-CASE

Curve follows the path of the outer curve

Curve balances the left-hand curve in size and shape

1 *Left-hand curve ending as it reaches the line.*

2 *Apex curve then straightening into a vertical.*

3 *Right-hand curve arching from the straight stem.*

Informal capital with 'manipulated' serifs. Gouache on watercolour paper with automatic pen

Versal roman form written with two strokes of narrow round hand pen. Ink on layout paper. May be filled in as required

Lombardic capital written with two strokes of thin round hand pen filled in, with strong contrast between thick and thin strokes

Uncial form lower-case double stroke Coit pen

Free roman capital. Gouache on layout paper using bamboo pen. Flourishes added with the corner of the pen

Humanistic cursive lower-case italic. Ink on layout paper using round hand nib

LOWER-CASE

Completed foundational upper-case 'M'.

Avoid pulling the pen uphill

Straighten to vertical leaving plenty of space inside the letter

End with an upward-arched serif

1 *A straight vertical stroke beginning with an arched serif.*

2 *A rounded arch, widening as it leaves the stem.*

3 *Repeat the arching shape of the second stroke to complete.*

Completed foundational lower-case 'm'.

LOWER-CASE

Completed italic upper-case 'M'.

Stroke straightens to leave a narrow counter

End with hooked serif

1 *Straight stroke beginning, but not ending with a hook.*

2 *Pull out a steep arch, emerging from the stem halfway up.*

3 *Repeat arching stroke and leave an identical counter.*

Completed italic lower-case 'm'.

LOWER-CASE

Completed uncial upper-case 'M'.

About 1½ nib widths between verticals

Arch springs from the straight stroke and continues to form a smooth curve

Curve counter-balances that on the left side

1 *Vertical straight stroke which begins with wedged serif.*

2 *Rounded arch straightening to form central vertical.*

3 *Complete with a curving arch which ends at base line.*

Completed uncial lower-case 'm'.

FOR LEFT-HANDERS

When using the underarm position (*see page 22*) you must avoid allowing the arm to lean too far to the left, as this will alter your perspective on the work, and make the letters too far away for them to be seen and written accurately.

Leaning too far to the left makes writing difficult

Squat italic upper- and lower-case with low x-height and flattened pen angle. Gouache on layout paper using square-ended brush

Informal alphabet. Ink on layout paper using a brush

Roman minuscule. Brown watercolour on layout paper using round hand nib

Italic upper- and lower-case with steepened pen angle and wide x-height. Ink on layout paper using round hand pen

Copperplate upper-case. Ink on layout paper using flexible pointed steel nib

Uncial variation upper-case. Ink on layout paper using round hand pen

Italic variation with low x-height. Ink on layout paper with round hand pen

N n

A series of waves drawn by the Egyptians to represent running water is the ancestor of 'N'. The symbol acquired a fish-like form in script, and was called 'Nun' or 'fish' in Phoenician. Eventually it became like a hook in shape, and the Greeks straightened it up to form 'Nu'. In the Roman form of 'N', the uprights are slightly narrower than the diagonal bar, giving it pleasing proportions without heaviness at the angles.

'N' reminded Victor Hugo of 'a gate closed by a diagonal bar'.

The lower-case form omits the final upright stroke and curves the diagonal to form an arch. The shape of this arch and the width of 'N' govern all the straight sided letters.

FOUNDATIONAL — UPPER-CASE

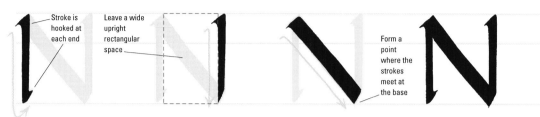

Stroke is hooked at each end

Leave a wide upright rectangular space

Form a point where the strokes meet at the base

1 *Vertical straight stroke made with a pen angle around 60°.*

2 *Repeat the first stroke but end where it touches the line.*

3 *With the pen at an angle of 45°, join the verticals.*

Completed foundational upper-case 'N'.

ITALIC — UPPER-CASE

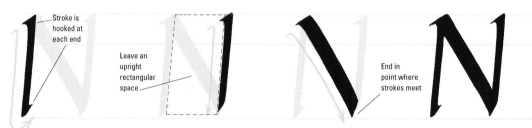

Stroke is hooked at each end

Leave an upright rectangular space

End in point where strokes meet

1 *With pen angle of 60°, make a straight slanted stroke.*

2 *Repeat the first stroke but end when it touches the base line.*

3 *Join verticals with straight diagonal, with pen at 45° angle.*

Completed italic upper-case 'N'.

UNCIAL — UPPER-CASE

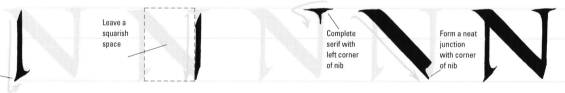

Ends in triangular serif drawn with left corner of nib

Leave a squarish space

Complete serif with left corner of nib

Form a neat junction with corner of nib

1 *Angle pen almost vertically for vertical straight stroke.*

2 *Repeat first stroke but end when the stroke touches the line.*

3 *Return nib to horizontal and add triangular serif.*

4 *Join verticals with diagonal, pen angle horizontal.*

Completed uncial upper-case 'N'.

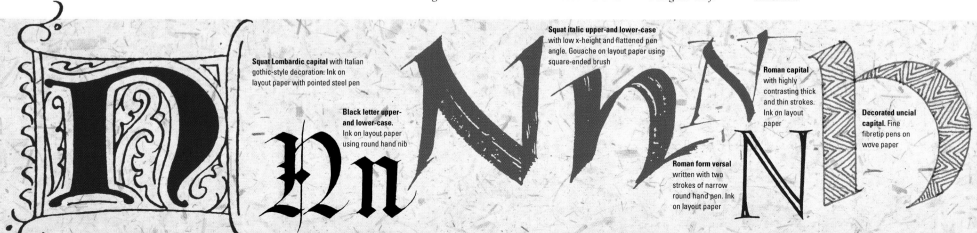

Squat Lombardic capital with Italian gothic-style decoration. Ink on layout paper with pointed steel pen

Black letter upper- and lower-case. Ink on layout paper using round hand nib

Squat italic upper-and lower-case with low x-height and flattened pen angle. Gouache on layout paper using square-ended brush

Roman form versal written with two strokes of narrow round hand pen. Ink on layout paper

Roman capital with highly contrasting thick and thin strokes. Ink on layout paper

Decorated uncial capital. Fine fibretip pens on wove paper

LOWER-CASE

1 *Vertical straight stroke beginning with an arched serif.*

Straight side ends in arched serif

2 *Rounded arch widens in thickness as soon as it leaves stem.*

Width of letter space compatible with h, m and u

Completed foundational lower-case 'n'.

LOWER-CASE

Arch relates to h, m and u in width and shape

1 *Make a slanted straight stroke hooked at top only.*

2 *Narrow arch, the straight side ending in a hooked serif.*

Completed italic lower-case 'n'.

LOWER-CASE

1 *Start with a vertical straight stem with wedged serif.*

2 *Rounded arch from stem, returning round to end at the base line.*

Completed uncial lower-case 'n'.

FOR LEFT-HANDERS

When writing in the underarm position (*see page 22*), be careful not to turn out at the elbow. This results in the arm leaning too far to the right, in a position that is much too restricted for writing well.

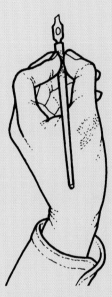

Elbow pointing outward results in awkward writing position

Eastern-style lower-case. Ink on layout paper using brush (bamboo pen may also be used)

Insular minuscule. Brown watercolour on layout paper using round hand nib

Copperplate upper- and lower-case. Ink on layout paper using flexible pointed steel nib

Informal alphabet. Ink on layout paper using a brush

Italic swash capital. Ink on layout paper using round hand nib

Italic lower-case letter. Gouache on handmade paper using quill

Humanistic cursive. Brown watercolour on layout paper using round hand nib

Modernized versal. Blue and green watercolour on Zerkall paper using two strokes of round hand pen

'O' has changed little since its origins – probably to be found in the circular Phoenician letter 'Ayin', standing for 'an eye'. The Greeks had two characters for 'O': 'great O', or 'Omega' is a horseshoe shape with feet, and ended their alphabet; 'Omicron' or 'little O' was often carved in a diamond shape and this character was later adopted by the Romans.

Geoffroy Tory wrote in 1529, that 'O' reminded him of the great amphitheatre in Rome, the Colosseum – 'circular outside and oval within'. Victor Hugo simply likened it to 'the sun'.

The rounded shape of the letter suggests its sound and pronunciation. Upper- and lower-case forms are alike, and 'O' governs the width and curve of all rounded letters – whether circular, flattened or elliptical.

Foundational – upper-case

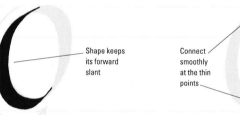

The overall shape is based on two overlapping circles. Do not pull to the left too early and distort the curve

Curve and connect stroke smoothly

1 *The first stroke widens as it leaves the top line.*

2 *Finish by completing the circle with the upper stroke.*

Completed foundational upper-case 'O'.

Italic – upper-case

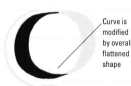

Shape keeps its forward slant

Connect smoothly at the thin points

1 *The left half of an ellipse, widening gradually towards the base.*

2 *Complete the ellipse with a balancing curve.*

Completed italic upper-case 'O'.

Uncial – upper-case

Curve is modified by overall flattened shape

The thinnest points of the circle overlap

1 *The left-hand curve more or less forms a semicircle.*

2 *Mirror the first curve to complete the circle as shown.*

Completed uncial upper-case 'O'.

Free roman capital with highly contrasting thick and thin strokes. Ink on layout paper using round hand nib

Versal roman form written with two strokes of narrow round hand pen. Ink on layout paper. May be filled in as required

Modernized versal written with two strokes of narrow round hand pen filled in. Gouache on calico. Based on runic inscriptions

Free roman capital. Gouache on layout paper using bamboo pen. Flourishes added with the corner of the pen

Squat Lombardic capital with Italian Gothic-style decoration. Ink on layout paper with pointed steel pen

Italic swash capital. Ink on layout paper using round hand nib

LOWER-CASE

The letter is based on two overlapping circles

Overlap at the thinnest points

1 *The first stroke is a generous curve at lower left.*

2 *Mirror the first curve to complete the circle.*

Completed foundational lower-case 'o'.

LOWER-CASE

Shape relates to that of 'c' and 'e'

1 *The left-hand side of a forward slanting ellipse.*

2 *Complete the ellipse with a balancing curve. Connect smoothly at the thin points.*

Completed italic lower-case 'o'.

LOWER-CASE

1 *Start with a semicircular left-hand curve.*

2 *Complete the flattened circle, overlapping thinnest points.*

Completed uncial lower-case 'o'.

FOR LEFT-HANDERS

Some letters present particular difficulty for left-handers when using underarm position 1. Large 'O's are difficult to join at the bottom right, as the joining point is obscured by the writing hand. It is of some help to continue the first stroke back uphill to right, part way, in order to have a visible place into which the second stroke can be joined.

Italic 'o' first stroke – extended uphill to right

Italic 'o' with successful join

Roman capital 'O' first stroke – extended uphill to right

Roman capital 'O' with successful join

Eastern-style. Ink on layout paper using brush (bamboo pen may also be used)

Italic upper-case with steepened pen angle and wide x-height. Ink on layout paper using round hand pen

Copperplate upper- and lower-case. Ink on layout paper using flexible pointed steel nib

Insular minuscule. Brown watercolour on layout paper using round hand nib

Black letter upper- and lower-case. Ink on layout paper using round hand nib

Informal alphabet. Ink on layout paper using a brush

Lombardic capital written with two strokes of thin round hand pen filled in

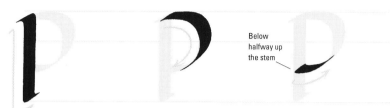

The Egyptian hieroglyph for a shutter was simplified by the scribes into a toothed character. This was called 'Pe' or 'mouth' by the Phoenicians, and further streamlined to form a hook. The Greeks reversed this and wrote 'Pi' as a squared arch, surviving in mathematics as a transcendental number relating to the geometry of a circle. By rounding the top and gradually curving it inwards, the Romans created 'P'. Its name and sound have changed little in our alphabet.

Victor Hugo likened the shape of 'P' to 'a porter, standing with a burden on his back'.

The lower-case form is similar to upper-case 'P', but with the bowl occupying the space between the lines and the tail descending below.

FOUNDATIONAL – UPPER-CASE

Below halfway up the stem

1 *Start with a vertical straight stem hooked at both ends.*

2 *Beginning at right angles to the stem, pull out semicircular bowl.*

3 *Finish by connecting to the bowl with a curved wedge.*

Completed foundational upper-case 'P'.

ITALIC – UPPER-CASE

Line returns to just below halfway down the stem

1 *Start with a slanted straight stem hooked at each end.*

2 *Form the upper corner of an ellipse at the top of the stem.*

3 *A curved wedge connects the bowl and the stem.*

Completed italic upper-case 'P'.

UNCIAL – UPPER-CASE

Stroke has wedged serif at each end

Curve begins just below the top line and ends at the base line

Wedge just touches the stem

1 *Straight vertical descending below base line.*

2 *Curve the semicircular bowl round from the stem.*

3 *A wedge drawn with a pen angle of 30°, connected to the bowl.*

Completed uncial upper-case 'P'.

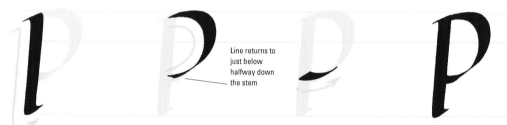

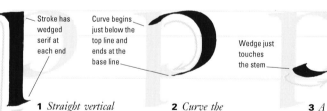

Squat italic upper- and lower-case with low x-height and flattened pen angle. Gouache on layout paper using square-ended brush

Copperplate upper- and lower-case. Ink on layout paper using flexible pointed steel nib

Roman capital written with two strokes of thin round hand pen filled in. Ink on layout paper

Free roman capital. Gouache on layout paper using bamboo pen. Flourishes added with the corner of the pen

Lombardic capital written with two strokes of thin round hand pen filled in, with strong contrast between thick and thin strokes

Roman form versal written with two strokes of narrow round hand pen. Ink on layout paper

LOWER-CASE

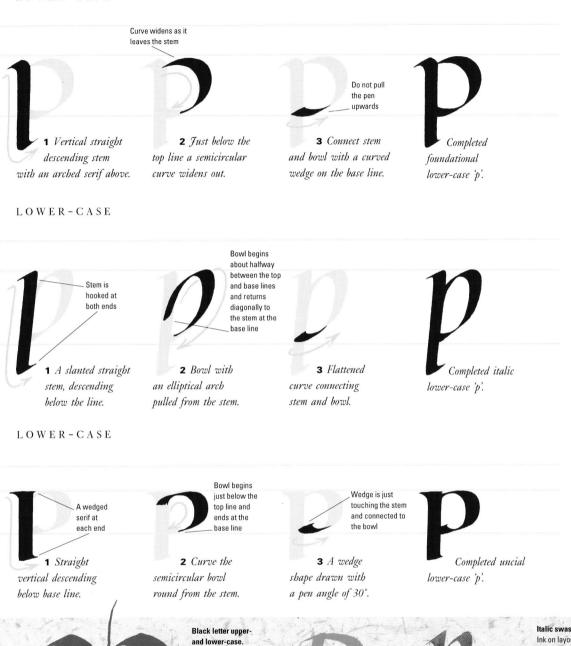

Curve widens as it leaves the stem

1 *Vertical straight descending stem with an arched serif above.*

2 *Just below the top line a semicircular curve widens out.*

Do not pull the pen upwards

3 *Connect stem and bowl with a curved wedge on the base line.*

Completed foundational lower-case 'p'.

LOWER-CASE

Stem is hooked at both ends

1 *A slanted straight stem, descending below the line.*

Bowl begins about halfway between the top and base lines and returns diagonally to the stem at the base line

2 *Bowl with an elliptical arch pulled from the stem.*

3 *Flattened curve connecting stem and bowl.*

Completed italic lower-case 'p'.

LOWER-CASE

A wedged serif at each end

1 *Straight vertical descending below base line.*

Bowl begins just below the top line and ends at the base line

2 *Curve the semicircular bowl round from the stem.*

Wedge is just touching the stem and connected to the bowl

3 *A wedge shape drawn with a pen angle of 30°.*

Completed uncial lower-case 'p'.

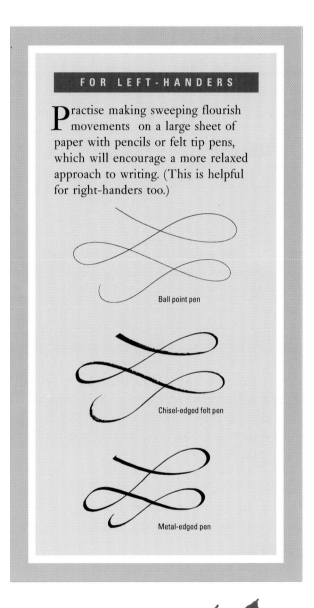

Black letter upper- and lower-case. Ink on layout paper using round hand nib

Italic swash capital. Ink on layout paper using round hand nib

Insular minuscule. Brown watercolour on layout paper using round hand nib

Humanistic cursive lower-case italic. Ink on layout paper using round hand nib

Informal alphabet. Ink on layout paper using a brush

Italic upper- and lower-case with steepened pen angle and wide x-height. Ink on layout paper using round hand pen

Flourished italic lower-case. Ink on Zerkall paper using round hand nib

Sharpened italic lower-case. Gouache on watercolour paper using Coit and automatic pens

In ancient Egypt, a hieroglyph representing a knee became scripted into a Q-like shape, and this was called 'Qoph' by the Phoenicians. It could have depicted one of several things – an ape with a hanging tail, the eye of a needle, an ear or a knot.

'Q' did not enter the Greek alphabet but was adopted by the Romans in perpetual combination with U. In *Champ Fleury,* Geoffroy Tory explained that 'Q' is the only letter with a tail, because it always has to be written with 'U', and in order to encourage him to follow, 'he embraces him with his tail'.

Although the upper-case is sometimes found in lower-case italic hands, exploiting the flourish of the tail, usually the lower-case letter has its tail descending from a straightened back.

FOUNDATIONAL – UPPER-CASE

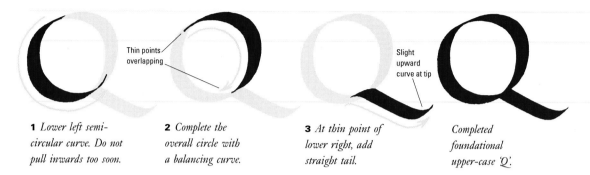

Thin points overlapping

Slight upward curve at tip

1 *Lower left semi-circular curve. Do not pull inwards too soon.*

2 *Complete the overall circle with a balancing curve.*

3 *At thin point of lower right, add straight tail.*

Completed foundational upper-case 'Q'.

ITALIC – UPPER-CASE

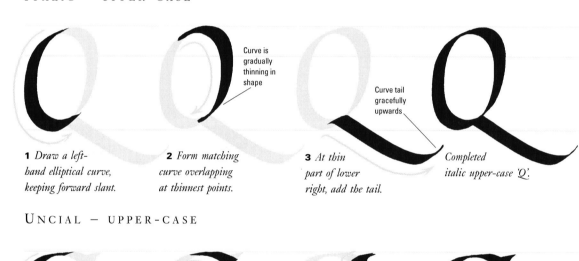

Curve is gradually thinning in shape

Curve tail gracefully upwards

1 *Draw a left-hand elliptical curve, keeping forward slant.*

2 *Form matching curve overlapping at thinnest points.*

3 *At thin part of lower right, add the tail.*

Completed italic upper-case 'Q'.

UNCIAL – UPPER-CASE

Curve is wedged shaped

Stem ends in wedged serif

1 *Semi-circular left-hand curve.*

2 *Apex curve, made with a pen angle of about 10°.*

3 *Vertical straight stem descends from top right.*

Completed uncial upper-case 'Q'.

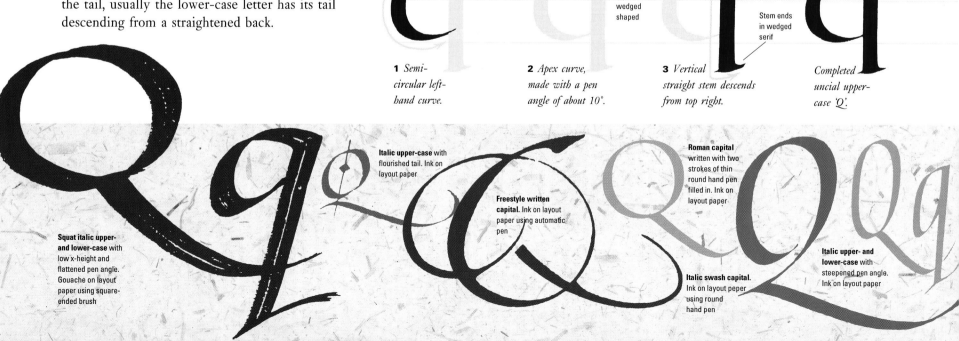

Squat italic upper- and lower-case with low x-height and flattened pen angle. Gouache on layout paper using square-ended brush

Italic upper-case with flourished tail. Ink on layout paper

Freestyle written capital. Ink on layout paper using automatic pen

Roman capital written with two strokes of thin round hand pen filled in. Ink on layout paper

Italic swash capital. Ink on layout paper using round hand pen

Italic upper- and lower-case with steepened pen angle. Ink on layout paper

LOWER-CASE

1 *Semi-circular lower left curve.*

2 *Flat-tened wedge apex curve.*

Tip of stroke touches top line

Hook at base of descender

3 *End with a vertical straight stroke.*

Completed foundational lower-case 'q'.

LOWER-CASE

1 *Elliptical wedge continued up towards top right corner.*

2 *Matching curve, thinning to overlap at base.*

Stem is hooked at the end

3 *Tail descending and curving upwards.*

Completed italic lower-case 'q'.

LOWER-CASE

1 *Form a semicircular left-hand curve.*

2 *Wedge-shaped apex curve – pen angle about 10°.*

3 *Descending vertical, led in from the right.*

Completed uncial lower-case 'q'.

FOR LEFT-HANDERS

A flourish on a tall ascender can be difficult for left-handers. For a tall flourish – perhaps on an important piece of work where no chances can be taken – the flourished ascender could be lightly pencilled in, after writing the letter body, to give a better chance of bringing the pen down in the right place! (*see below*).

Three stages in writing a tall flourished 'd'

1 Write letter body

2 Pencil in ascender

3 Write ascender and it's flourish

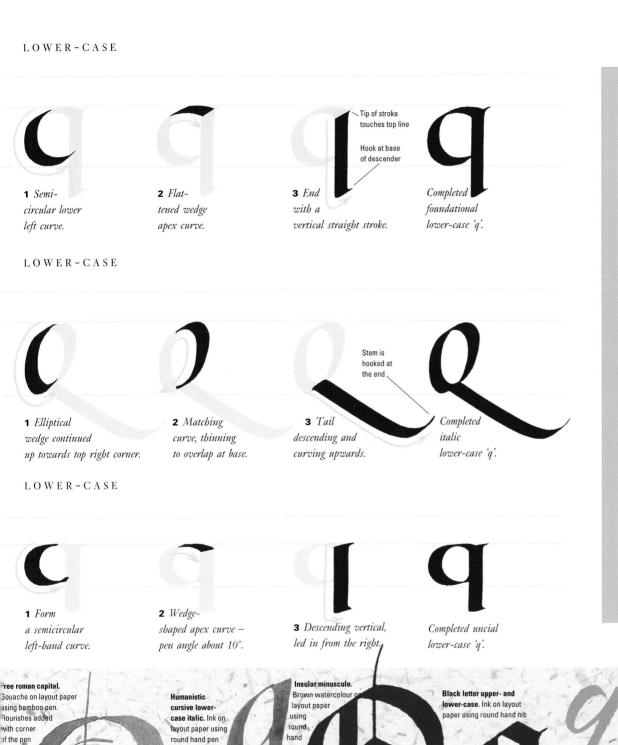

Free roman capital. Gouache on layout paper using bamboo pen. Flourishes added with corner of the pen

Humanistic cursive lower-case italic. Ink on layout paper using round hand pen

Insular minuscule. Brown watercolour on layout paper using round hand nib

Black letter upper- and lower-case. Ink on layout paper using round hand nib

Informal alphabet. Ink on layout paper using a brush

Freestyle capital written in ink on layout paper with a brush

Copperplate upper-case. Ink on layout paper using flexible pointed steel nib

Rr

The Egyptian hieroglyph for a mouth has probably descended to become letter 'R'. The Phoenicians angularized it into the shape of number four – 'Resh'. By reversing it and rounding its projection, the Greeks formed 'Rho'. It had no need for a tail, as 'Pi' was already represented by an arch, and the 'P'-shaped letter was sufficient. However, a tail was added by the Romans to form 'R'.

The porter seen by Victor Hugo in 'P' seems to have finally come to rest in 'R', and is now leaning on his stick.

'R' has many variations in sound according to language and accent. The upper- and lower-case forms also differ greatly; the loop forgotten and the reduced tail added to the top of the stem in 'r'. This dates back to an uncial form which combined loop and tail in one long diagonal stroke.

FOUNDATIONAL – UPPER-CASE

Curve returns to meet stem just below halfway down

Vertical straight stem is hooked at each end.

Rounded curve begins at a right angle to top of stem.

Connect stem and bowl with flattened curved wedge.

From thin part of bowl, extend straight tail, hooked at its tip.

Completed foundational upper-case 'R'.

ITALIC – UPPER-CASE

Ellipse meets stem at a steep angle

Tail curving upwards slightly at the tip.

Slanting straight stem hooked at both ends.

Draw ellipse pulled from top of stem to re-meet it halfway down.

From the thin part of the bowl, extend the tail.

Completed italic upper-case 'R'.

UNCIAL – UPPER-CASE

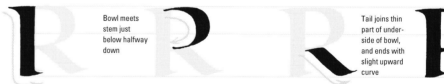

Bowl meets stem just below halfway down

Tail joins thin part of under-side of bowl, and ends with slight upward curve

Vertical straight stroke with wedged serif.

Semicircular bowl pulled at right angle from stem.

Straight tail drawn with pen angled at 10°, connects to bowl.

Completed uncial upper-case 'R'.

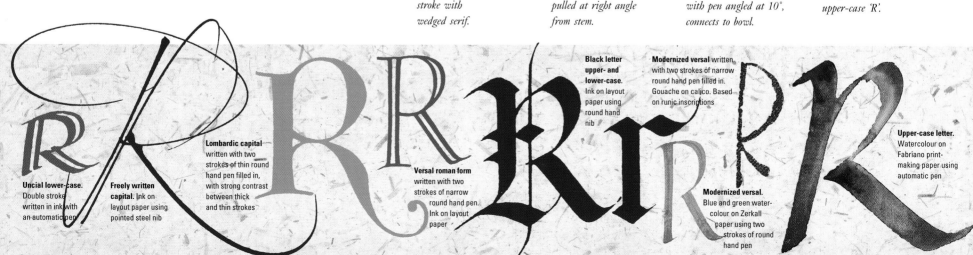

Uncial lower-case. Double stroke written in ink with an automatic pen.

Freely written capital. Ink on layout paper using pointed steel nib

Lombardic capital written with two strokes of thin round hand pen filled in, with strong contrast between thick and thin strokes

Versal roman form written with two strokes of narrow round hand pen. Ink on layout paper

Black letter upper- and lower-case. Ink on layout paper using round hand nib

Modernized versal written with two strokes of narrow round hand pen filled in. Gouache on calico. Based on runic inscriptions

Modernized versal. Blue and green water-colour on Zerkall paper using two strokes of round hand pen

Upper-case letter. Watercolour on Fabriano print-making paper using automatic pen

LOWER-CASE

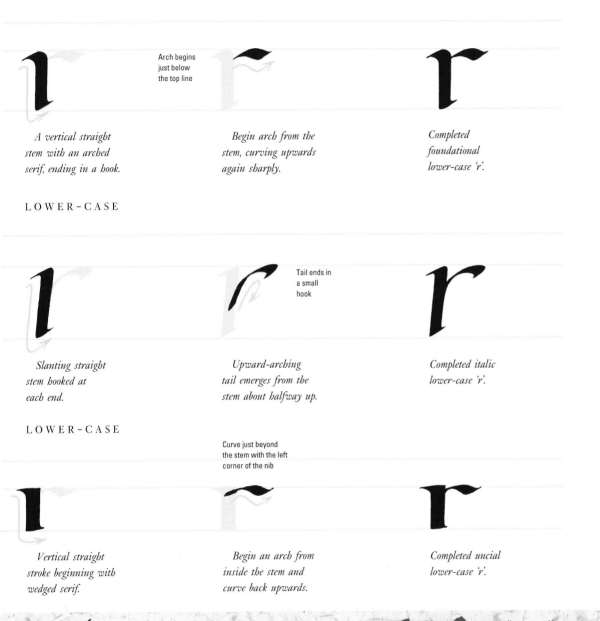

Arch begins
just below
the top line

*A vertical straight
stem with an arched
serif, ending in a hook.*

*Begin arch from the
stem, curving upwards
again sharply.*

*Completed
foundational
lower-case 'r'.*

LOWER-CASE

Tail ends in
a small
hook

*Slanting straight
stem hooked at
each end.*

*Upward-arching
tail emerges from the
stem about halfway up.*

*Completed italic
lower-case 'r'.*

LOWER-CASE

Curve just beyond
the stem with the left
corner of the nib

*Vertical straight
stroke beginning with
wedged serif.*

*Begin an arch from
inside the stem and
curve back upwards.*

*Completed uncial
lower-case 'r'.*

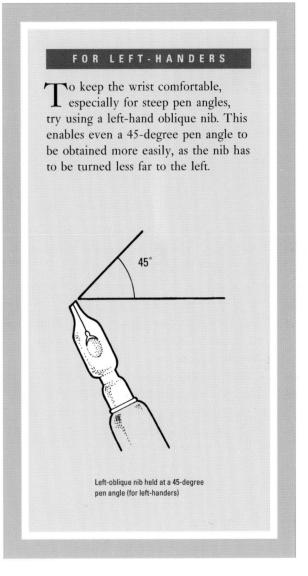
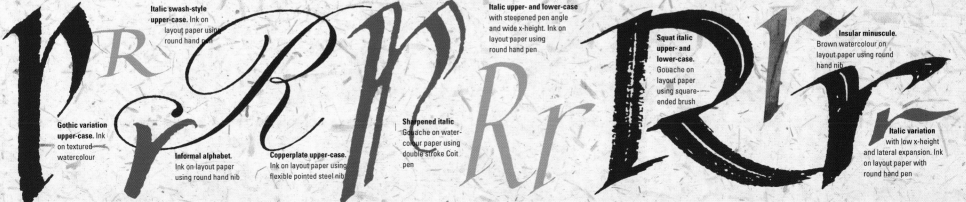

**Italic swash-style
upper-case.** Ink on
layout paper using
round hand pen

Italic upper- and lower-case
with steepened pen angle
and wide x-height. Ink on
layout paper using
round hand pen

**Squat italic
upper- and
lower-case.**
Gouache on
layout paper
using square-
ended brush

Insular minuscule.
Brown watercolour on
layout paper using round
hand nib

**Gothic variation
upper-case.** Ink
on textured
watercolour

Informal alphabet.
Ink on layout paper
using round hand nib

Copperplate upper-case.
Ink on layout paper using
flexible pointed steel nib

Sharpened italic.
Gouache on water-
colour paper using
double stroke Coit
pen

Italic variation
with low x-height
and lateral expansion. Ink
on layout paper with
round hand pen

S s

The sound of water swishing in the reeds was depicted by the Egyptians as papyrus plants growing out of two parallel lines. In running hand this became like a row of teeth and the Phoenicians called it 'Shin'. This developed into a squat W and when placed on its side by the Greeks, 'Sigma' was formed. The Romans rounded the angles and omitted the final base stroke.

The sound of 'S' caused Geoffroy Tory to think of a 'hot iron when it is plunged into water', and Victor Hugo both saw and heard 'a snake'.

In calligraphy, upper- and lower-case forms are generally similar, although the italic straightened curve, with an attached lead-in stroke, gave rise to the copperplate scripted shape.

FOUNDATIONAL – UPPER-CASE

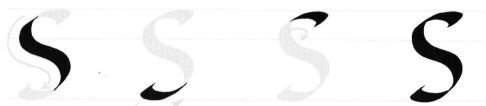

1 *Smooth double-curve, varying little from its diagonal centre.*

2 *A hooked curve completes the lower bowl.*

3 *A small hooked curve completes the slightly smaller upper bowl.*

Completed foundational upper-case 'S'.

ITALIC – UPPER-CASE

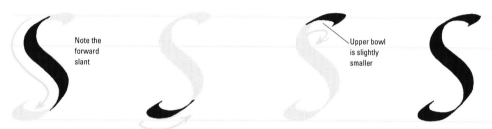

Note the forward slant

Upper bowl is slightly smaller

1 *A smooth double curve with almost straight diagonal.*

2 *A hooked flattened curve forms the lower bowl.*

3 *A hooked flattened curve completes the upper bowl.*

Completed italic upper-case 'S'.

UNCIAL – UPPER-CASE

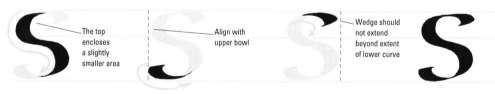

The top encloses a slightly smaller area

Align with upper bowl

Wedge should not extend beyond extent of lower curve

1 *Two small semi-circular curves, linked by a shallow diagonal.*

2 *An inward curving wedge completes the lower bowl.*

3 *An inward curving wedge completes the upper bowl.*

Completed uncial upper-case 'S'.

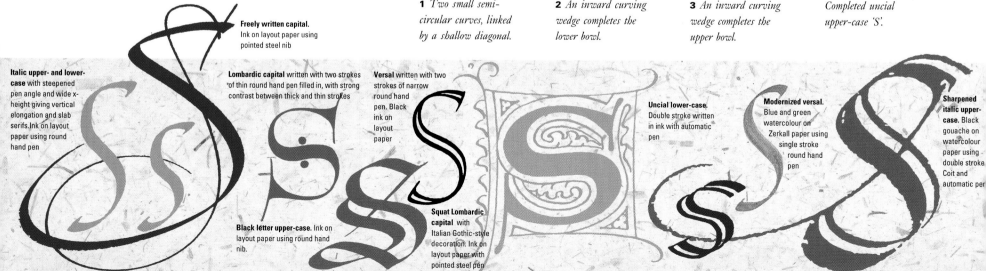

Freely written capital. Ink on layout paper using pointed steel nib

Italic upper- and lower-case with steepened pen angle and wide x-height giving vertical elongation and slab serifs. Ink on layout paper using round hand pen

Lombardic capital written with two strokes of thin round hand pen filled in, with strong contrast between thick and thin strokes

Black letter upper-case. Ink on layout paper using round hand nib.

Versal written with two strokes of narrow round hand pen. Black ink on layout paper

Squat Lombardic capital with Italian Gothic-style decoration. Ink on layout paper with pointed steel pen

Uncial lower-case. Double stroke written in ink with automatic pen

Modernized versal. Blue and green watercolour on Zerkall paper using single stroke round hand pen

Sharpened italic upper-case. Black gouache on watercolour paper using double stroke. Coit and automatic pen

LOWER-CASE

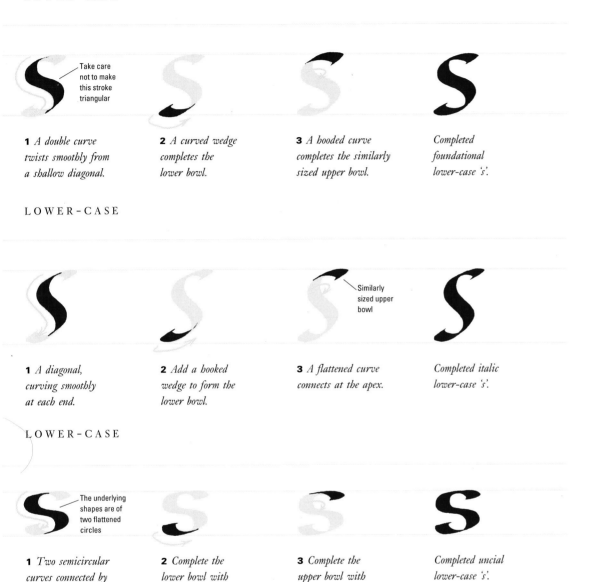

Take care not to make this stroke triangular

1 *A double curve twists smoothly from a shallow diagonal.*

2 *A curved wedge completes the lower bowl.*

3 *A hooded curve completes the similarly sized upper bowl.*

Completed foundational lower-case 's'.

LOWER-CASE

1 *A diagonal, curving smoothly at each end.*

2 *Add a hooked wedge to form the lower bowl.*

Similarly sized upper bowl

3 *A flattened curve connects at the apex.*

Completed italic lower-case 's'.

LOWER-CASE

The underlying shapes are of two flattened circles

1 *Two semicircular curves connected by a shallow diagonal.*

2 *Complete the lower bowl with a curved wedge.*

3 *Complete the upper bowl with a hooked curve.*

Completed uncial lower-case 's'.

FOR LEFT-HANDERS

When writing at a large-scale, particularly with large automatic or Coit pens in positions one and three, left-handers have to take care not to smudge the writing, as the hand sweeps up and down the paper in the large writing movements. The hand may sometimes have to be taken right off the paper in some situations to avoid smudging the work, as trial and error will show.

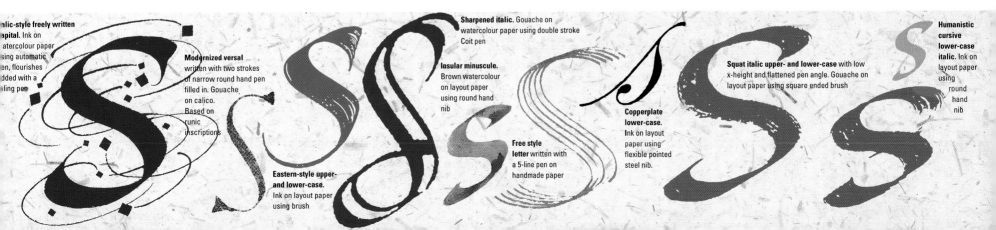

Italic-style freely written capital. Ink on watercolour paper using automatic pen, flourishes added with a ruling pen

Modernized versal written with two strokes of narrow round hand pen filled in. Gouache on calico. Based on runic inscriptions

Eastern-style upper- and lower-case. Ink on layout paper using brush

Sharpened italic. Gouache on watercolour paper using double stroke Coit pen

Insular minuscule. Brown watercolour on layout paper using round hand nib

Free style letter written with a 5-line pen on handmade paper

Copperplate lower-case. Ink on layout paper using flexible pointed steel nib.

Squat italic upper- and lower-case with low x-height and flattened pen angle. Gouache on layout paper using square ended brush

Humanistic cursive lower-case italic. Ink on layout paper using round hand nib

Stem begins just inside the bar

1 *With a hook at each end, draw a wide horizontal bar.*

2 *Drop the straight vertical stem from the centre, hooked at base.*

Completed foundational upper-case "T".

ITALIC — UPPER-CASE

A noose, or perhaps a tongue, was represented by the hieroglyphic origin of 'T'. The Phoenicians converted this into a cross with four equal arms, used to signify the ownership of an animal.

The Greek letter 'Tau' was formed by removing the vertical top bar, although this remains, much reduced, in the lower case form.

An alternative form of the capital, deriving from uncial practice, has a large curved back with the addition of a horizontal top bar. This may help to compensate for the large empty spaces left each side of 'T' 's vertical stem. Normally, neighbouring letters should be placed slightly closer together.

Victor Hugo likened 'T', in 1839, to 'a hammer'.

Stem is hooked at its base

1 *A short horizontal bar, hooked at each end.*

2 *Slanted straight stem, dropped from the centre of the bar.*

Completed italic upper-case "T".

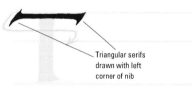

UNCIAL — UPPER-CASE

Triangular serifs drawn with left corner of nib

Ends in a wedged serif

1 *With a 10° pen angle, draw a wide horizontal bar.*

2 *Drop vertical stem from the centre of bar, with pen at horizontal.*

Completed uncial upper-case "T".

Roman capital with highly contrasting thick and thin strokes. Ink on layout paper using round hand pen

Freely written capital. Ink on layout paper using script pen

Modernized versal. Blue and green watercolour on Zerkall paper using two strokes of round hand pen

Black letter upper- and lower-case. Ink on layout paper using round hand nib

Squat italic upper- and lower-case with low x-height and flattened pen angle. Gouache on layout paper using square ended brush

Uncial upper-case. Double stroke written in ink with automatic pen

Humanistic cursive lower-case italic. Ink on layout paper using round hand nib

Lombardic capital written with two strokes of thin round hand pen filled in, with strong contrast between thick and thin strokes. Uncial form

Informal capital with 'manipulated serifs'. Gouache on watercolour paper with automatic pen

LOWER-CASE

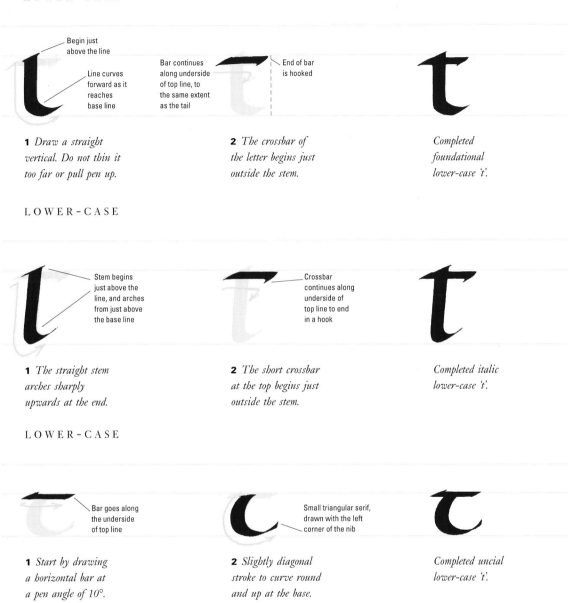

- Begin just above the line
- Line curves forward as it reaches base line
- Bar continues along underside of top line, to the same extent as the tail
- End of bar is hooked

1 *Draw a straight vertical. Do not thin it too far or pull pen up.*

2 *The crossbar of the letter begins just outside the stem.*

Completed foundational lower-case 't'.

LOWER-CASE

- Stem begins just above the line, and arches from just above the base line
- Crossbar continues along underside of top line to end in a hook

1 *The straight stem arches sharply upwards at the end.*

2 *The short crossbar at the top begins just outside the stem.*

Completed italic lower-case 't'.

LOWER-CASE

- Bar goes along the underside of top line
- Small triangular serif, drawn with the left corner of the nib

1 *Start by drawing a horizontal bar at a pen angle of 10°.*

2 *Slightly diagonal stroke to curve round and up at the base.*

Completed uncial lower-case 't'.

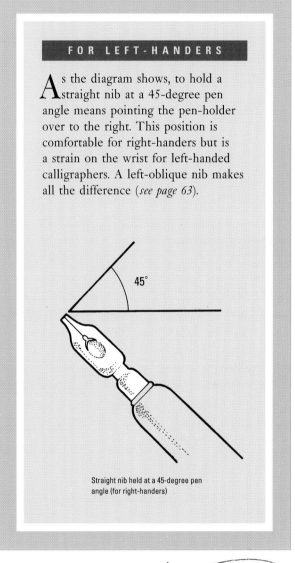

FOR LEFT-HANDERS

As the diagram shows, to hold a straight nib at a 45-degree pen angle means pointing the pen-holder over to the right. This position is comfortable for right-handers but is a strain on the wrist for left-handed calligraphers. A left-oblique nib makes all the difference (*see page 63*).

45°

Straight nib held at a 45-degree pen angle (for right-handers)

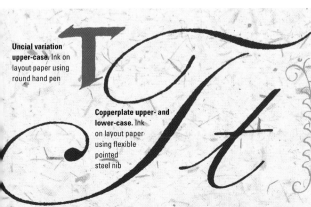

Uncial variation upper-case. Ink on layout paper using round hand pen

Copperplate upper- and lower-case. Ink on layout paper using flexible pointed steel nib

Squat Lombardic capital with Italian Gothic-style decoration. Ink on layout paper with pointed steel pen

Informal alphabet. Ink on layout paper using a brush

Free roman capital. Gouache on layout paper using bamboo pen. Flourishes added with the corner of the pen

Freely drawn capital with automatic pen

Versal upper-case written with two strokes of narrow round hand pen. Ink on layout paper

Italic variation with low x-height and lateral expansion. Ink on layout paper with round hand pen

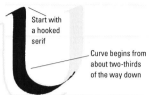

Foundational — upper-case

1 Start with a hooked serif

Curve begins from about two-thirds of the way down

1 *A straight vertical stem which curves round smoothly.*

2 Overlap with thin part of left-hand stroke

2 *Right stroke begins vertically, curving smoothly towards base. Space is that of a wide, upright rectangle.*

Completed foundational upper-case 'U'.

Italic — upper-case

1 Stroke curves diagonally, then sharply upwards

1 *Beginning with a hook, make a slanted straight stroke.*

2 Stroke begins straight and gradually narrows

2 *The right stroke connects with the thin part of the bowl.*

Completed italic upper-case 'U'.

Uncial — upper-case

1 Curve begins with a wedged serif

1 *Sharp outward curve continues smoothly round at base.*

2 *Vertical straight stem with wedged serifs at both ends.*

Completed uncial upper-case 'U'.

'U' descends, like 'F', from the Egyptian 'Cerastes' or 'horned asp', and the Phoenician 'Wau' – a peg. The Greeks did not adopt this letter, and in Latin 'U' and 'V' were not distinguished, and 'V' was used for both vowel and consonant sounds. This confusing practice survived well into the Middle Ages, although both letter forms were known.

The rounded base of 'U' suggested 'an urn' to Victor Hugo, writing in *Travel Notebooks*.

There are close similarities between upper- and lower-case forms of 'U', and the straight-backed stem on the right can be used for both.

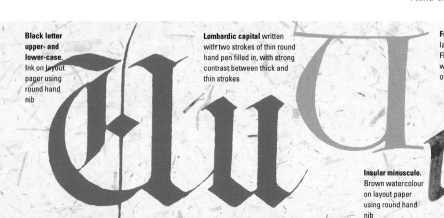

Black letter upper- and lower-case. Ink on layout paper using round hand nib

Lombardic capital written with two strokes of thin round hand pen filled in, with strong contrast between thick and thin strokes

Insular minuscule. Brown watercolour on layout paper using round hand nib

Free roman capital. Gouache on layout paper using bamboo pen. Flourishes added with the corner of the pen

Humanistic cursive lower-case italic. Ink on layout paper using round hand nib

Italic upper- and lower-case with steepened pen angle and wide x-height giving vertical elongation and slab serifs. Ink on layout paper using round hand pen

Versal roman form written with two strokes of narrow round hand pen. Ink on layout paper

LOWER-CASE

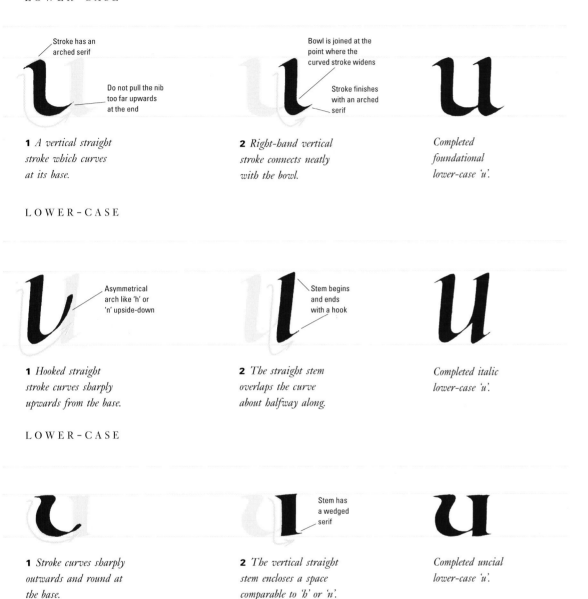

Stroke has an arched serif

Do not pull the nib too far upwards at the end

1 *A vertical straight stroke which curves at its base.*

Bowl is joined at the point where the curved stroke widens

Stroke finishes with an arched serif

2 *Right-hand vertical stroke connects neatly with the bowl.*

Completed foundational lower-case 'u'.

LOWER-CASE

Asymmetrical arch like 'h' or 'n' upside-down

1 *Hooked straight stroke curves sharply upwards from the base.*

Stem begins and ends with a hook

2 *The straight stem overlaps the curve about halfway along.*

Completed italic lower-case 'u'.

LOWER-CASE

1 *Stroke curves sharply outwards and round at the base.*

Stem has a wedged serif

2 *The vertical straight stem encloses a space comparable to 'h' or 'n'.*

Completed uncial lower-case 'u'.

FOR LEFT-HANDERS

Writing to music helps encourage rhythm in the writing for all calligraphers, but is especially useful to left-handers as it helps to lessen any tension that may build up during writing caused by an exacting pen hold.

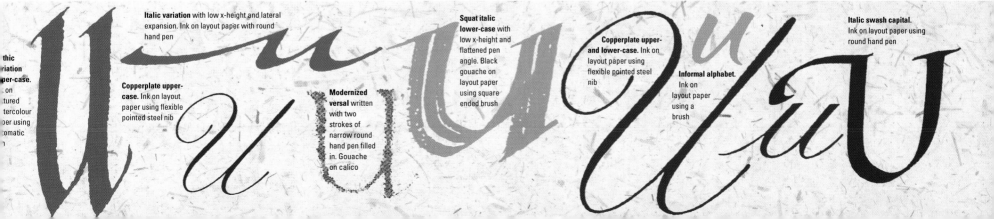

thic riation per-case. on tured tercolour er using omatic

Copperplate upper-case. Ink on layout paper using flexible pointed steel nib

Italic variation with low x-height and lateral expansion. Ink on layout paper with round hand pen

Modernized versal written with two strokes of narrow round hand pen filled in. Gouache on calico

Squat italic lower-case with low x-height and flattened pen angle. Black gouache on layout paper using square ended brush

Copperplate upper- and lower-case. Ink on layout paper using flexible pointed steel nib

Informal alphabet. Ink on layout paper using a brush

Italic swash capital. Ink on layout paper using round hand pen

The hieroglyph 'Cerastes' or 'horned asp', called 'Wau' by the Phoenicians, provided the origins for 'F', 'U', 'V' and 'W'. The Latin form, used only briefly by the Greeks, came about through the greater ease of carving two straight lines with a chisel, then making the rounded form of a 'U'. The Romans used 'V' for number five.

In the second century AD, 'V' began to be used at the beginning of a word and 'U' elsewhere, but the same sound was interchangeable for the two letters until the late sixteenth century.

The lower-case is generally like the upper-, but sometimes in italic, 'v' has a curved base and an inwardly curving second side.

Victor Hugo called 'V' 'a vase'.

FOUNDATIONAL — UPPER-CASE

Meeting in a point at the base

1 *A straight diagonal stroke, drawn with a pen angle of 45°.*

2 *A matching fine diagonal stroke – pen angle around 30°.*

Completed foundational upper-case 'V'.

ITALIC — UPPER-CASE

Meeting in a point at the base

1 *A steep diagonal stroke, drawn with a pen angle of 45°.*

2 *A thin stroke – pen angle 30°, at marginally shallower angle.*

Completed italic upper-case 'V'.

UNCIAL — UPPER-CASE

Stroke is drawn out with the left corner of the nib to form a point on the base line

Second stroke meets the first at its point

Triangular serif finished with left corner of nib

1 *Begin the letter with a straight diagonal stroke.*

2 *With a pen angle of 45°, draw a matching straight stroke.*

3 *Pull the pen horizontal and complete by forming serif.*

Completed uncial upper-case 'V'.

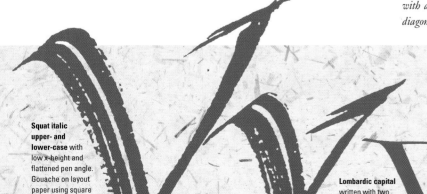
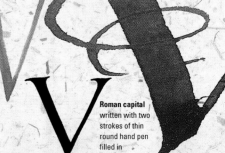

Squat italic upper- and lower-case with low x-height and flattened pen angle. Gouache on layout paper using square ended brush

Lombardic capital written with two strokes of thin round hand pen filled in, with strong contrast between thick and thin strokes

Roman form versal written with two strokes of narrow round hand pen. Ink on layout paper

Modernized versal. Blue and green watercolour on Zerkhall paper using two strokes of round hand pen

Roman capital written with two strokes of thin round hand pen filled in

Free roman capital. Gouache on layout paper using bamboo pen. Flourishes added with the corner of the pen

LOWER-CASE

Strokes join at
a sharp point

1 *Straight diagonal
stroke with pen angle
of about 45°.*

2 *Reflecting diagonal
with pen angle of 30°,
joining the first.*

*Completed
foundational
lower-case 'v'.*

LOWER-CASE

Meeting in
a point at
the base

1 *A broad diagonal
stroke, made at a pen
angle of 45°.*

2 *A slim diagonal
stroke made with
a pen angle of 40°.*

*Completed italic
lower-case 'v'.*

LOWER-CASE

The counter should form
an equilateral triangle

Complete
stroke with left
corner of nib

Strokes join at a
sharp angle

1 *Stop the diagonal
stroke just above the
base line.*

2 *Mirrored diagonal
is written with
a pen angle of 45°.*

3 *Add a triangular
serif with the left
corner of the nib.*

*Completed uncial
lower-case 'v'.*

FOR LEFT-HANDERS

The chisel-edged brush is a useful writing tool for beginners, and especially for left-handers, helping to lighten the touch and to get an easy flow over the paper as it does not offer so much resistance to the writing surface as a metal pen. A large brush is good for letter form practice and also to use in combination with edged-pen calligraphy in finished designs.

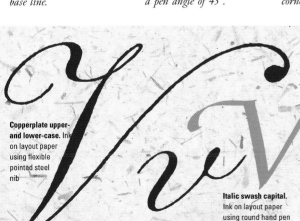 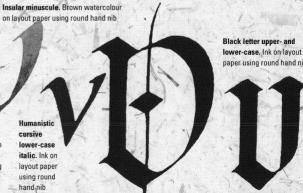

Copperplate upper- and lower-case. Ink on layout paper using flexible pointed steel nib

Italic swash capital. Ink on layout paper using round hand pen

Informal alphabet. Ink on layout paper using a brush

Italic upper- and lower-case with steepened pen angle and wide x-height. Ink on layout paper using round hand pen

Insular minuscule. Brown watercolour on layout paper using round hand nib

Humanistic cursive lower-case italic. Ink on layout paper using round hand nib

Black letter upper- and lower-case. Ink on layout paper using round hand nib

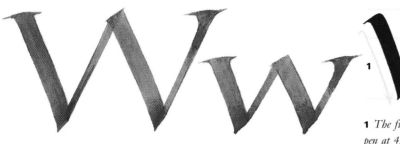

FOUNDATIONAL – UPPER-CASE

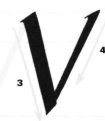

Strokes overlap only at the very top

Stroke begins with a hook

1 Strokes meet in a point at the base

1 *The first diagonal is drawn with pen at 45° angle.* **2** *Return to a pen angle of 30° for reflecting diagonal.*

3 *The third stroke repeats the first in width and angle.* **4** *Fourth stroke repeats narrow second stroke.*

Completed foundational upper-case 'W'.

ITALIC – UPPER-CASE

1 *A steep diagonal stroke with pen angle of 45°.* **2** *Return to 30° for thin stroke, which meets first at a point.*

3 *Repeat first stroke overlapping the tip of the second stroke.* **4** *Repeat the second stroke. Begin with a hooked serif.*

Completed italic upper-case 'W'.

UNCIAL – UPPER-CASE

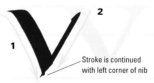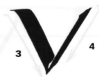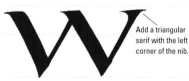

Stroke is continued with left corner of nib

Add a triangular serif with the left corner of the nib.

1 *Diagonal stroke, ends just above base line.* **2** *Reflecting stroke at 45° angle meets first stroke at the point.*

3 *Third, wide stroke, overlaps the top of second stroke.* **4** *Fourth narrow stroke, meets third in a point.*

Completed uncial upper-case 'W'.

Like 'U' and 'V', 'W' derives from the Egyptian 'horned asp' or 'Cerastes', which became the Phoenician hooked letter 'Wau'. As its name implies, 'double-u' may be formed from two 'U's, but is more often 'double-v'. 'V' was known as 'single-u' until the seventeeth century. The Romans did not use the letter 'W' and it rarely appears in Latin languages. Consequently, neither Tory nor Hugo includes it in their descriptions.

'W' also has Norse origins and appears in words with Germanic and Scandinavian roots. In German it is pronounced like the English 'V', while the English pronunciation is the same as 'V' in Latin.

Upper- and lower-case forms are both alike, although sometimes the latter has rounded lower arches. In most circumstances it is not necessary to cross, or clearly overlap the two central diagonals, as this creates an overcrowded area which will jar in a line of text.

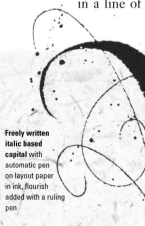

Freely written italic based capital with automatic pen on layout paper in ink, flourish added with a ruling pen

Double stroke Gothic inspired letter form. Ink on layout paper

Lombardic capital written with two strokes of thin round hand pen filled in, with strong contrast between thick and thin strokes

Modernized versal written with two strokes of narrow round hand pen filled in. Gouache on calico. Based on runic inscriptions

LOWER-CASE

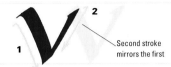
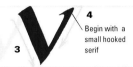

Second stroke
mirrors the first

Begin with a
small hooked
serif

1 *The first diagonal is drawn with a pen angle of 45°.* **2** *Return to an angle of 30° for a narrow second stroke.*

3 *Repeat wider first stroke, overlapping only at the very top point.* **4** *Repeat the second stroke in weight and angle.*

Completed foundational lower-case 'w'.

LOWER-CASE

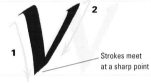

Strokes meet
at a sharp point

1 *The first diagonal, drawn at a pen angle of 45°, is steeply sloped.* **2** *Return to angle of 30° for second, thin stroke.*

3 *Overlapping tip of second stroke, repeat the first stroke.* **4** *Lead in with a hooked serif. Repeat the second stroke.*

Completed lower-case italic 'w'.

LOWER-CASE

Stroke continued
with left corner of
nib to form a point

Strokes
overlap slightly

A triangular serif
is drawn with the
corner of the nib

1 *First diagonal stroke ends just above the line.* **2** *Second, mirroring stroke at 45° angle. Strokes meet at a point.*

3 *The third stroke repeats the first diagonal.* **4** *The fourth stroke repeats the second diagonal.*

Completed lower-case uncial 'w'.

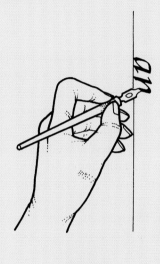

FOR LEFT-HANDERS

The diagram shows how writing in left-handed position 2 (*see pages 23–4*), in which the hand is held in a 'natural' position with the paper turned round, is made easier by the use of a left-hand oblique nib.

Writing vertically,
using a left-oblique nib

Copperplate upper- and lower-case. Ink on layout paper using flexible pointed steel nib

Black letter upper- and lower-case. Ink on layout paper using round hand nib

Italic upper-case with steepened pen angle and wide x-height giving vertical elongation and slab serifs. Ink on layout paper using round hand pen

Roman form versal upper-case written with two strokes of narrow round hand pen. Ink on layout paper. May be filled in as required

Humanistic cursive lower-case italic. Ink on layout paper using round hand nib

Italic variation with low x-height and lateral expansion. Ink on layout paper with round hand pen

Squat italic upper case with low x-height and flattened pen angle. Gouache on layout paper using square ended brush

Informal alphabet. Ink on layout paper using a brush

'X' has its origins in the Egyptian hieroglyph for a chairback. This was extended with crossbars by the scribes and Phoenicians, and was known as 'Samekh'. The Greeks created two letters from this – the triple horizontal bars of 'Xi' and the X-shaped 'Chi'. This accounts for different pronunciations of the letter.

The Romans used 'X' to represent the number ten, and the early Christians played upon the coincidence of its cross shape and 'Chi' beginning the name of 'Christ'.

Victor Hugo saw 'crossed swords, and combat' in the letter, and as the outcome was unclear, 'X' became a symbol of the unclear – 'the mystical sign of destiny'.

In both the upper- and lower-cases, the same letter forms are found, although these are sometimes more curved in the small letters.

FOUNDATIONAL – UPPER-CASE

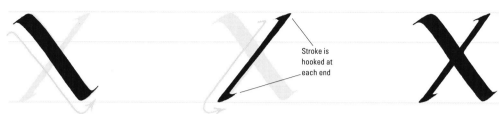

Stroke is hooked at each end

1 *Draw a straight diagonal stroke with a pen angle of 45°.*

2 *Bisect the stroke with a straight thin stroke – pen angle 30°.*

Completed foundational upper-case 'X'.

ITALIC – UPPER-CASE

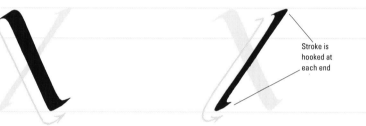

Stroke is hooked at each end

1 *A straight, steeply sloped diagonal made with pen angle of 45°.*

2 *At a 30° pen angle, bisect first stroke with a thin stroke.*

Completed italic upper-case 'X'.

UNCIAL – UPPER-CASE

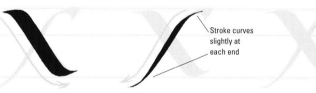

Stroke curves slightly at each end

1 *A shallow diagonal stroke with small lead-in and out.*

2 *At a 45° pen angle cross the first stroke at a matching angle.*

3 *At 45°, add a short hooked curve at apex of the second stroke.*

Completed uncial upper-case 'X'.

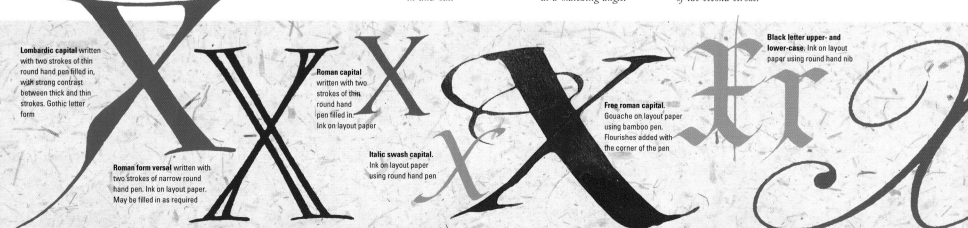

Lombardic capital written with two strokes of thin round hand pen filled in, with strong contrast between thick and thin strokes. Gothic letter form

Roman form versal written with two strokes of narrow round hand pen. Ink on layout paper. May be filled in as required

Roman capital written with two strokes of thin round hand pen filled in. Ink on layout paper

Italic swash capital. Ink on layout paper using round hand pen

Free roman capital. Gouache on layout paper using bamboo pen. Flourishes added with the corner of the pen

Black letter upper- and lower-case. Ink on layout paper using round hand nib

LOWER-CASE

Slight hooks leading in and out

1 *A straight diagonal made with the pen at an angle of 45°.*

2 *Thin hooked reflecting stroke – pen at 30° – bisects first stroke.*

Completed foundational lower-case 'x'.

LOWER-CASE

 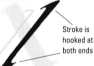

Stroke is hooked at both ends

1 *Make a straight diagonal stroke, with pen at 45° angle.*

2 *Cross with a slightly steeper diagonal, drawn with pen angle of 30°.*

Completed italic lower-case 'x'.

LOWER-CASE

Stroke tails off below the base line

1 *Form the first sweeping diagonal stroke.*

2 *Cross it with a similar thin stroke, with the pen at 45°.*

3 *Still at 45°, add a short hooked curve at apex of the thin stroke.*

Completed uncial lower-case 'x'.

Humanistic cursive lower-case italic. Ink on layout paper using round hand nib

Copperplate upper- and lower-case. Ink on layout paper using flexible pointed steel nib

Italic upper- and lower-case. Black ink on layout paper using round hand pen

Informal alphabet. Ink on layout paper using a brush

Squat italic upper- and lower-case with low x-height and flattened pen angle. Gouache on layout paper using square ended brush

Freely written capital. Ink on layout paper using brush

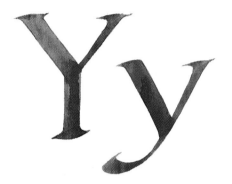

Once again, 'Y' is derived from the horned asp of ancient Egypt, and the horns and body are still apparent. The Greeks converted the Phoenician letter 'Wau' into 'Epsilon' but the Romans did not adopt 'Y' and it is not often found in languages derived from Latin.

In Middle English 'y' with its tail was used in place of 'i' at the end of words where it remains to this day. 'Y' was also used to represent the 'th' sound, hence the archaic form 'Ye' for 'the'.

Victor Hugo saw many images in 'Y', for example, 'a tree, the fork of two roads, the head of a donkey, and a man who prays to the heavens, raising his arms'.

In uncial script the top of 'Y' was curved and filled the space between the lines, with a descending tail. This letter form was continued in lower-case usage, and still retains its tail, usually written at a diagonal slant.

FOUNDATIONAL – UPPER-CASE

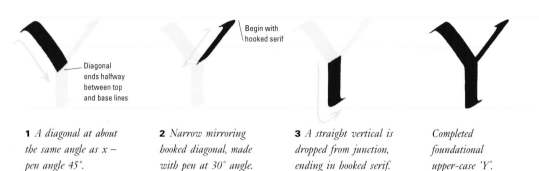

Diagonal ends halfway between top and base lines

Begin with hooked serif

1 *A diagonal at about the same angle as x – pen angle 45°.*

2 *Narrow mirroring hooked diagonal, made with pen at 30° angle.*

3 *A straight vertical is dropped from junction, ending in hooked serif.*

Completed foundational upper-case 'Y'.

ITALIC – UPPER-CASE

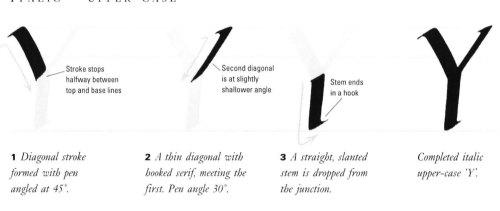

Stroke stops halfway between top and base lines

Second diagonal is at slightly shallower angle

Stem ends in a hook

1 *Diagonal stroke formed with pen angled at 45°.*

2 *A thin diagonal with hooked serif, meeting the first. Pen angle 30°.*

3 *A straight, slanted stem is dropped from the junction.*

Completed italic upper-case 'Y'.

UNCIAL – UPPER-CASE

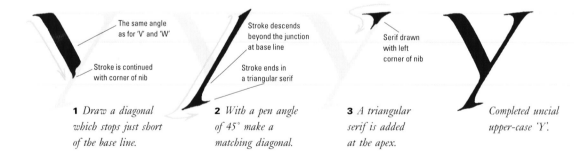

The same angle as for 'V' and 'W'

Stroke descends beyond the junction at base line

Serif drawn with left corner of nib

Stroke is continued with corner of nib

Stroke ends in a triangular serif

1 *Draw a diagonal which stops just short of the base line.*

2 *With a pen angle of 45° make a matching diagonal.*

3 *A triangular serif is added at the apex.*

Completed uncial upper-case 'Y'.

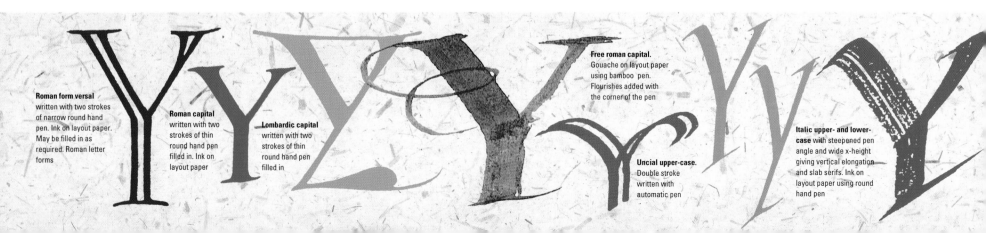

Roman form versal written with two strokes of narrow round hand pen. Ink on layout paper. May be filled in as required. Roman letter forms

Roman capital written with two strokes of thin round hand pen filled in. Ink on layout paper

Lombardic capital written with two strokes of thin round hand pen filled in

Free roman capital. Gouache on layout paper using bamboo pen. Flourishes added with the corner of the pen

Uncial upper-case. Double stroke written with automatic pen

Italic upper- and lower-case with steepened pen angle and wide x-height giving vertical elongation and slab serifs. Ink on layout paper using round hand pen

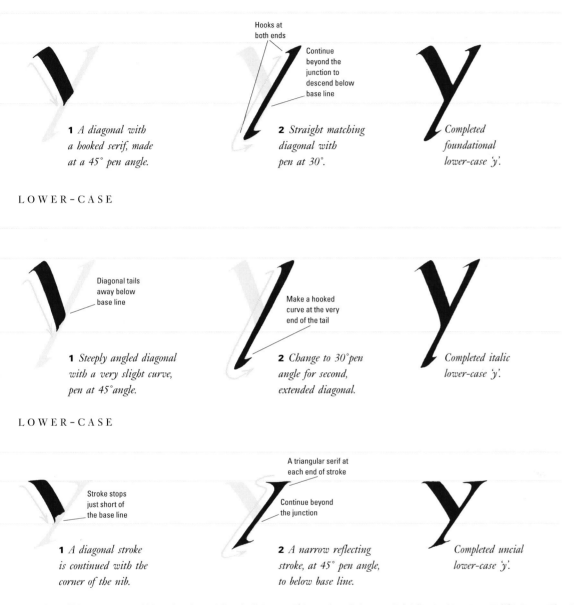

LOWER-CASE

1 *A diagonal with a hooked serif, made at a 45° pen angle.*

Hooks at both ends

Continue beyond the junction to descend below base line

2 *Straight matching diagonal with pen at 30°.*

Completed foundational lower-case 'y'.

LOWER-CASE

Diagonal tails away below base line

1 *Steeply angled diagonal with a very slight curve, pen at 45° angle.*

Make a hooked curve at the very end of the tail

2 *Change to 30°pen angle for second, extended diagonal.*

Completed italic lower-case 'y'.

LOWER-CASE

Stroke stops just short of the base line

1 *A diagonal stroke is continued with the corner of the nib.*

A triangular serif at each end of stroke

Continue beyond the junction

2 *A narrow reflecting stroke, at 45° pen angle, to below base line.*

Completed uncial lower-case 'y'.

FOR LEFT-HANDERS

Left-handed people should position their drawing boards so that the light comes from the right. This will ensure that their hands don't create a shadow over their work and will provide the best possible light to work in. (Conversely, of course, right-handed people should have the light source to the left.) Take advantage of daylight when you can, and work in natural light, sitting with the window to the right. Otherwise, use a desk lamp placed in this position.

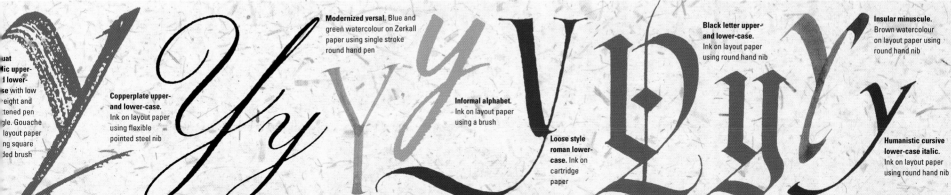

Squat italic upper- and lower-case with low height and flattened pen angle. Gouache on layout paper using square ended brush

Copperplate upper- and lower-case. Ink on layout paper using flexible pointed steel nib

Modernized versal. Blue and green watercolour on Zerkall paper using single stroke round hand pen

Informal alphabet. Ink on layout paper using a brush

Loose style roman lower-case. Ink on cartridge paper

Black letter upper- and lower-case. Ink on layout paper using round hand nib

Insular minuscule. Brown watercolour on layout paper using round hand nib

Humanistic cursive lower-case italic. Ink on layout paper using round hand nib

In Egyptian hieroglyphics, the pictogram for a duck became a flattened I shape in hieratic script. This was carried on by the Phoenicians and the vertical became diagonal, joining the horizontals at the corners. In the Greek alphabet, 'Zeta' was the seventh letter, and so it continued in early Latin scripts, but was soon abandoned. 'Z' was retained by certain scholars, however, and eventually returned to the Roman alphabet, at the end.

In English country dialects the letter was sometimes known as 'Izzard'.

Victor Hugo concluded his imaginative alphabet by saying 'Z is lightning, it is God'.

'Z' is the same in upper- and lower-case forms and the character varies little between different calligraphic hands. The diagonal stroke is almost always drawn with the nib at a horizontal angle, to achieve the necessary weight.

FOUNDATIONAL – UPPER-CASE

1 *Draw a wide horizontal bar on the underside of top line.*

2 *A similar horizontal, curled slightly at the very end.*

3 *With horizontal pen angle, draw a diagonal joining the corners.*

Completed foundational upper-case 'Z'.

ITALIC – UPPER-CASE

1 *Begin with a short horizontal, with hooked lead-in.*

2 *Similar horizontal placed slightly to the left, with hooked lead-out.*

3 *Hold the pen at a flattened angle for the diagonal joining stroke.*

Completed italic upper-case 'Z'.

UNCIAL – UPPER-CASE

1 *A triangular serif, begun at 30°, filled in with left nib corner.*

2 *Horizontal bars drawn at a pen angle of 30°.*

3 *Form a triangular serif with the pen still at a 30° angle.*

4 *Hold pen horizontally, for diagonal.*

Diagonal joins

Completed uncial upper-case 'Z'.

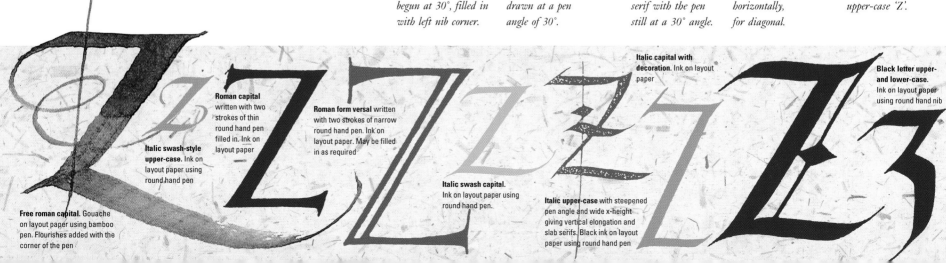

Free roman capital. Gouache on layout paper using bamboo pen. Flourishes added with the corner of the pen

Italic swash-style upper-case. Ink on layout paper using round hand pen

Roman capital written with two strokes of thin round hand pen filled in. Ink on layout paper

Roman form versal written with two strokes of narrow round hand pen. Ink on layout paper. May be filled in as required

Italic swash capital. Ink on layout paper using round hand pen.

Italic capital with decoration. Ink on layout paper

Italic upper-case with steepened pen angle and wide x-height giving vertical elongation and slab serifs. Black ink on layout paper using round hand pen

Black letter upper- and lower-case. Ink on layout paper using round hand nib

LOWER-CASE

1 *Draw a horizontal bar on the underside of the top line.*

2 *Form a similar horizontal on the base line.*

3 *Make the linking diagonal with the pen at a horizontal angle.*

Completed foundational lower-case 'z'.

LOWER-CASE

1 *A short horizontal along the underside of the top line.*

2 *A second short horizontal on the base line.*

3 *Diagonal joining stroke with pen held at a flattened angle.*

Completed italic lower-case 'z'.

LOWER-CASE

Triangular serif

1 *Horizontal drawn at 30° pen angle on the underside of top line.*

2 *A similar horizontal stroke is drawn on the base line.*

Line joins horizontals at corners

3 *With a horizontal pen angle, draw a linking diagonal.*

Completed uncial lower-case 'z'.

FOR LEFT-HANDERS

When you are more experienced you may like to try making and writing with a quill.

Goose, swan and turkey feathers all make good quills for general purposes, while crow and duck feathers are excellent for fine work. For left-handed calligraphers the feathers from the right wing of the bird are naturally curved to suit.

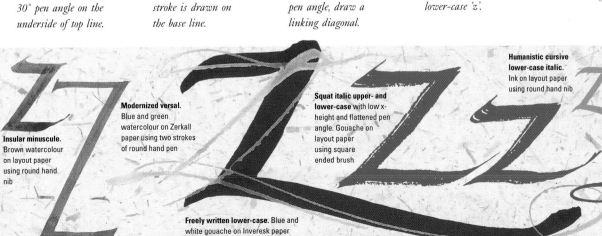

Insular minuscule. Brown watercolour on layout paper using round hand nib

Modernized versal. Blue and green watercolour on Zerkall paper using two strokes of round hand pen

Freely written lower-case. Blue and white gouache on Inveresk paper using marker pen and ruling pen

Squat italic upper- and lower-case with low x-height and flattened pen angle. Gouache on layout paper using square ended brush

Humanistic cursive lower-case italic. Ink on layout paper using round hand nib

Informal alphabet. Ink on layout paper using a brush

Copperplate upper- and lower-case. Ink on layout paper using flexible pointed steel nib

Numerals

Roman numerals, based on letters of the alphabet, are often seen on clock faces, chapter headings and in writing the date, while Arabic notation, using nine single digits, is more generally used elsewhere. Numerals are adapted to suit the forms of each alphabet, based on the shape of 'O'. Individual numerals stay between the lines or have ascenders and descenders, depending on the context and the character of the script. Usually even numbers and nought ascend, and odd numbers (except for one), descend. They are written somewhere between the lower- and upper-case in x-height.

FOUNDATIONAL NUMERALS

X-HEIGHT: *5½ nib widths*
NO ASCENDERS OR DESCENDERS
PEN ANGLE: *30 degrees*
SLOPE: *vertical*

Diagonal at 30°

1 *Wedged serif curving into vertical upright.*

2 *Upright filling top corner and hooked at base.*

Straightening to diagonal halfway down

1 *Tightly curved wedge.*

2 *Semi-circular curve at about 45° stroke.*

3 *Horizontal bar hooked at the end.*

Upper right half of circle

1 *Horizontal stroke along top line.*

2 *Diagonal at 45°, reversing halfway down.*

3 *Flattened, hooked curve joining at base.*

Ends in a hook

1 *Straight diagonal starting from top line.*

2 *Horizontal bar ⅔ of the way down.*

3 *Straight stem ending in a hook.*

Forms upper part of circle

1 *Vertical straight stroke changing halfway down.*

2 *Flattened curve overlapped slightly at base.*

3 *Horizontal along underside of top line.*

Ends in a hook

Curve widens slightly towards base

1 *Vertically elongated curve, curving upwards.*

2 *Semicircle, beginning ⅔ up the stem.*

Connecting with stem at base.

3 *Curved wedge at apex.*

1 *Horizontal top bar on underside of top line.*

2 *Straight diagonal ending in hooked serif.*

1 *Double curve with rounded terminations.*

2 *Rounded curve completing smaller upper bowl.*

Lower bowl is larger

3 *Lower left half of a semi-circle completes lower bowl.*

Curves up at the end

1 *Lower left half of circle from top line to just below halfway down.*

Extends into curved point

2 *Elongated curve joining bowl at top and base.*

3 *Flattened curve connecting at base line.*

1 *Slightly elongated curve, between lines.*

The numeral is narrower than the circular letter 'O'

2 *Complete oval with matching curve.*

1234567890

ITALIC NUMERALS

X-HEIGHT: *5 nib widths*

ASCENDERS AND DESCENDERS:
2 or 3 nib widths (variable)

PEN ANGLE: *40 degrees*

SLOPE: *5 degrees from vertical*

Angled towards base

Avoid exaggerated point at junction

Straightens into diagonal halfway down

1 *Wedged serif at 45° with curve from tip.*

2 *Slanted straight stroke.*

3 *Small slab serif pulled from tip of stem.*

1 *Tightly curved wedge beginning above top line.*

2 *Shallow upright curve, at about 45°.*

3 *Horizontal base line turned up slightly at tip.*

Forms half-elliptical descending curve

Slight upward curve

1 *Horizontal top stroke along underside of top line.*

2 *Diagonal straight stroke, turning sharply ⅔ of the way down.*

3 *Flattened curve connecting at base.*

1 *Steepened diagonal starting above top line.*

2 *Horizontal bar ½ to ⅔ of the way down.*

3 *Vertical straight stroke ending in a hook.*

Angled ⅔ of the way down

Elliptical curve descends below base line

Hook

Ends in hook

1 *Slanted straight stroke, from top line.*

2 *Flattened curve over-lapping at base.*

3 *Horizontal top bar just under top line.*

1 *Elliptical curve beginning above top line.*

2 *Right side of an ellipse added on.*

3 *Flattened curve with wedged serif.*

1 *Horizontal top bar just below top line.*

2 *Straight diagonal to below base line.*

3 *Flat serif ending in upward curve.*

Tails off at each end in curved point

Curves up just above base line

Tails off below base line

The numeral is wider than letter '0'

1 *Slanted double curve beginning above top line.*

2 *Upper part of ellipse completing upper bowl.*

3 *Lower part of ellipse completing lower bowl.*

1 *Left side of ellipse beginning at top line.*

2 *Elliptical curve connected to bowl at each end.*

3 *Wedged curve connecting at base.*

1 *Beginning above line, form left side of an ellipse.*

2 *Complete ellipse with matching curve which is not too narrow.*

1234567890

UNCIAL NUMERALS

> **X-HEIGHT:** *4 nib widths*
> **ASCENDERS AND DESCENDERS:**
> *1 nib width*
> **PEN ANGLE:** *horizontal*
> **SLOPE:** *vertical*

Turn towards the vertical

1 *Wedged serif – pull pen backwards then curve it down.*

2 *Vertical stroke filling top corner with minimal serif at base.*

1 *Short flattened semicircle curving from above top line.*

Straightens to a shallow diagonal

2 *Joined at the apex, form a wide extended curve.*

Ends in small triangular serif

3 *Nib angle 20° for wide horizontal base stroke.*

1 *Horizontal stroke along underside of the top line, nib 20°.*

Diagonal reaches ⅔ down between the lines
Semicircle descends below base line

2 *Diagonal, angled to form flattened descending semicircle.*

3 *Curved wedge connecting at base.*

Begins above top line

1 *45° diagonal stroke with pen held at 30° angle.*

Bar ends in a hook

2 *Pen held at 20° for horizontal bar ⅔ of the way down.*

3 *Vertical straight stroke, ending in flat serif.*

Angled to form flattened semicircle
Descends below the base line

1 *Vertical straight stroke, ⅔ of the way down.*

2 *Hooked, curved wedge, connecting at base.*

Bar just under top line
Short triangular serif

3 *Nib angled at 20° for horizontal top bar.*

Widens towards base line

1 *Flattened curve beginning above top line.*

Connects at base of letter

2 *Pulled out from stem, rounding into right-hand semi-circle between lines.*

3 *Small triangular serif at apex of numeral.*

1 *Nib angle 20° for horizontal bar, just below top line.*

Descends below base line, ends in flat hook at its base

2 *Nib horizontal for descending straight diagonal.*

Changes direction ¼–⅓ down from top line

1 *Beginning above top line, double curve of two flattened semi-circles.*

2 *A flattened semi-circle completing the upper bowl.*

3 *A flattened semi-circle completing the lower bowl.*

1 *Left half of flattened semicircle, ending ¾ of the way down between top and base lines.*

Ends in flat serif

2 *Flattened curve straightening into diagonal, descending below line.*

1 *Flattened semi-circle from top to base line.*

2 *Complete with a matching curve to form a circle.*

1 2 3 4 5 6 7 8 9 0

Ampersands and accents

The ampersand is a combined upper-case 'E' and lower-case 't', from 'et' – the Latin for 'and'. It can be simple, as in one of the many italic forms, or highly stylized: in the foundational form the 'E' became almost a tailed figure-of-eight, with a curved serif.

Ampersands are very useful as a means of compressing lengthy lines of text or decoratively combining two names or the words of a title. They usually ascend to the full height of the capital letters. Be careful if the word 'and' is really intended, such as in a line of poetry, where the Latin 'et' would be anachronistic.

Other contractions, such as the dipthong AE, are found in many European languages, as well as accents and signs which modify the existing letters to create additional sounds. Most are confined to the lower-case.

FOUNDATIONAL

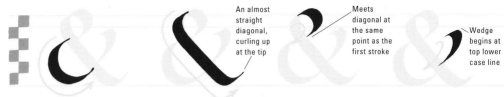

An almost straight diagonal, curling up at the tip

Meets diagonal at the same point as the first stroke

Wedge begins at top lower case line

1 *Lower left half of a circle, beginning just below the top line of the lower-case.*

2 *The tail descends from a rounded curve above the top line of the upper-case.*

3 *The top bowl is completed with a small semicircle, meeting the diagonal.*

4 *A curved wedge is added to the tail, to line up with base of lower bowl.*

ITALIC

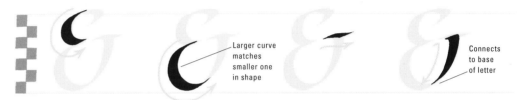

Larger curve matches smaller one in shape

Connects to base of letter

1 *Elliptical curve, to just below top line of the lower-case.*

2 *Curve brought up at base line with left corner of nib.*

3 *Flat serif placed along top line of lower-case.*

4 *Elongated curved wedge extending from serif.*

UNCIAL

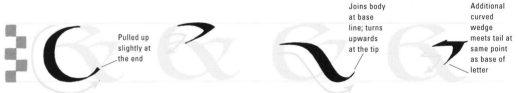

Joins body at base line; turns upwards at the tip

Additional curved wedge meets tail at same point as base of letter

Pulled up slightly at the end

1 *Left-hand flattened semicircle between top and base upper-case lines.*

2 *Flattened apex curve returns at angle, forming diagonal stroke.*

3 *Crossbar extending to meet the bowl of the 'e', then curving diagonally.*

4 *Nib angle at 20° for horizontal bar attached to the tail just beyond the bowl.*

Æxàêíøüçß;

1

Ææàêíøüçß;

2

Ææàêíøüçß;

3

Dipthongs and accents for: **1** *Foundational alphabet* **2** *Italic alphabet* **3** *Uncial alphabet*

Serifs

Serifs provide a visual lead-in and lead-out for straight-stemmed letters. They are also a comfortable way of getting the ink to flow, often establishing the overall nib angle and the underlying form of the letters. There are several different serif forms, some more widely used than others, and some used only in certain writing styles. They should not be made over-large, particularly on lower-case letters, or they will overwhelm the basic structure. They are illustrated here on stems of upper-case height. It is possible to combine two related forms, such as wedge above and hook below.

Foundational and italic
For both foundational and italic, the most successful serifs are usually the flick, the hook and the arch, as these are minimal and will not interrupt the writing rhythm or legibility. The inner serifs of 'h', 'm', 'n' and 'u' should be kept especially small and neat.

Uncial
The uncial hand has only two specific serifs, owing to its squat character and horizontal nib angle: the wedge and its more triangular form.

Other forms
More complex examples are better suited to ascenders and upper-case characters. Used with caution, they may add a decorative character to a heading or short text. The built-up roman serif, for example, is based on the brush and chiselled forms of square roman capitals and is best kept within this context.

FOUNDATIONAL SERIFS

Slightly rounded arch

HOOK

Gradually rounded arch

ARCH

1 Short horizontals formed with flattened pen angle

SLAB

2. Vertical stem with pen angle of 30°
3. Horizontal at base formed with flattened pen angle

1 Short horizontals with nib at 30°. Serif grows from tip of stem, but without exaggerating the junction

FLAG

2 Stem grows from right corner of upper serif
3 Short horizontals with nib at 30°

1 Upwards fine stroke at 30°
2 Arching stroke curving to vertical
3 Vertical straight stem ending in hooked serif

WEDGE

1 Top slab horizontal stroke
2 Vertical stem slightly curved at tip and base
3 Slab horizontal at base
4 Arching curve from left

BUILT-UP ROMAN

ITALIC SERIFS

Straight, fine upward strokes at 40°

FLICK

Tight curved arch at top and base

HOOK

1. Upward fine stroke at 40°
2. Stem drawn from upper corner, ending in hook

WEDGE

3 Small arch curving into vertical

1 Short horizontal stroke
2 Join on stem

FLAG

3 Extend stem base into serif but do not exaggerate junction by curving stem tip too much

1 Horiztonal slab serif
2 Arching curve into slanted stem tailing off at tip
3 Horizontal slab serif

BUILT-UP ROMAN

4 Curve slope filling right corners

1 Short horizontal at flattened pen angle
2 Stem stroke at 40°
3 Flattened serif at base

SLAB

UNCIAL SERIFS

1 Horizontal fine stroke to lead in
2 Curved stroke forms wedge, becoming vertical to end in flattened base hook
3 Minimal right-hand curve fills in corner

WEDGE

1 Horizontal fine lead-in stroke
2 Vertical straight stem, ending in flattened hook
3 Short diagonal, forming triangular wedge at apex

TRIANGULAR

Flourishes

Flourishes are not suitable for uncial and foundational scripts but are an elegant and original way of adding decoration to italic lettering. The copy books of Renaissance writing masters display great dexterity in the control of quill and pen, creating intricate patterns and pictorial designs. However, it is not too difficult to create attractive effects by building on the ascenders and descenders of the lower-case letters and the extended strokes of the 'swash' capitals.

Flourishes should be light and airy, and kept well away from the body of the letter. Try to keep the curves elliptical and balanced, in keeping with the forms of the italic hand. If possible, make the adjacent diagonal strokes parallel, and avoid more than two strands crossing over at any one point.

Begin with pencil designs to see what will work. These may be traced through layout paper using a fine nib (size 5, 4, 3½), loaded with plenty of ink so that it will flow freely. It is easier to build up the strokes by pulling the pen naturally rather than attempting a complex flourish all in one go. With practice and plenty of movement in the arm, flowing and spontaneous flourishes will be achieved, and a repertoire of successful curves may be developed.

FLOURISHES

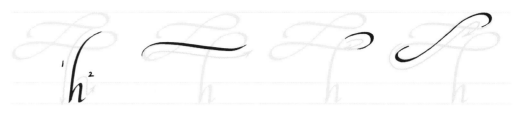

Upright ascender to right

Diagonal ascender to right

Descender to right

Descender to left

Gaudeamus igitur
Juvenes dum sumus.
Post jucundam juventutum.
Post molestam senectutum.
Nos habebit humus.

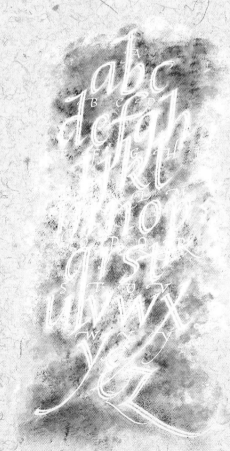

Projects

The following pages show six finished
projects, both decorative and useful,
together with a step-by-step breakdown
of how they were designed and executed,
specifying the pens, brushes, inks, paints,
gold-leaf and other materials used to
make them.

The layout of a short poem

The layout of a simple poem or quotation is an essential calligraphic skill which can be built upon in more complex projects. Mounted and framed, the result makes an attractive panel to display on the wall or give as a present. Choose a text which inspires or interests you and try a variety of treatments in order to arrive at a final solution. Remember to keep the historical context and the intentions of the author in mind as you develop the design.

Gaudeamus igitur is a well known Latin student song dating back to the twelfth century. Although foundational is a formal hand, it has a likeable roundness which is appropriate to the architecture of the period. It is a good teaching hand which also suits the mood of the piece.

In laying out the poem, I eventually settled on a balanced but asymmetrical layout and enlarged the first line both in capitals, and in upper- and lower-case letters. I also experimented with a less formal centred layout using italic capitals moving slightly up and down, and very little interlinear space. To add interest to the piece, '*Gaudeamus igitur*' was added in tiny diagonal gold letters in three places.

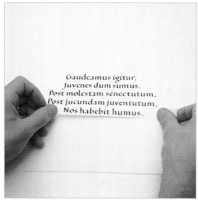

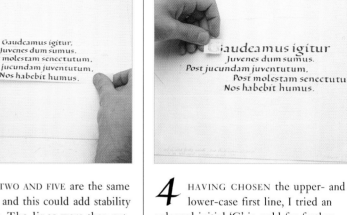

2 LINES TWO AND FIVE are the same length and this could add stability to the design. The lines were then cut into lengths and rearranged. A centred layout seemed best, but lines three and four were brought out each side and placed just within the extent of lines two and five.

4 HAVING CHOSEN the upper- and lower-case first line, I tried an enlarged initial 'G' in gold for further emphasis and decoration. The loose pieces were glued in a paste-up onto a sheet of layout paper now the design was satisfactory.

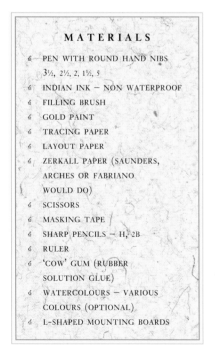

MATERIALS

- PEN WITH ROUND HAND NIBS 3½, 2½, 2, 1½, 5
- INDIAN INK – NON WATERPROOF
- FILLING BRUSH
- GOLD PAINT
- TRACING PAPER
- LAYOUT PAPER
- ZERKALL PAPER (SAUNDERS, ARCHES OR FABRIANO WOULD DO)
- SCISSORS
- MASKING TAPE
- SHARP PENCILS – H, 2B
- RULER
- 'COW' GUM (RUBBER SOLUTION GLUE)
- WATERCOLOURS – VARIOUS COLOURS (OPTIONAL)
- L-SHAPED MOUNTING BOARDS

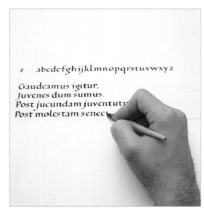

1 THE TEXT was written out straightforwardly in foundational on layout paper, ranged left, using a 3½ round hand nib. The lines are fairly even in length, and the similar pattern of words in lines three and four could be emphasized. However, the first is too short, and this is not visually pleasing.

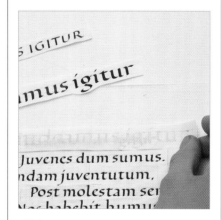

3 TO EXPERIMENT with other effects, '*Gaudeamus igitur*' was next written out with the same nib but in capitals, then at the same weight (four nib widths) but in a larger pen, and again in gold. Many variations are possible within one script: upper- and lower-case, different sizes and other colours.

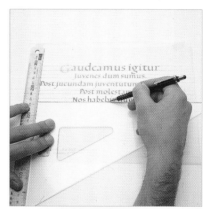

5 THE WRITING LINE system was traced from the paste-up, with equal interlinear spaces. The beginning and end of each line of text were marked on the tracing. By drawing on the back of the trace, this was transferred lightly onto a sheet of Zerkall printmaking paper.

ADDITIONAL STAGES

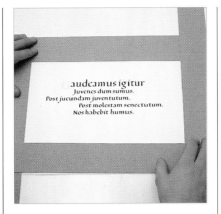

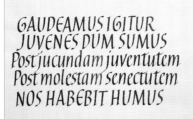

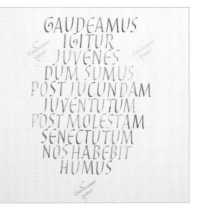

6 THE PASTE-UP was folded beneath the first line and taped with masking tape onto the final paper just above the writing lines. Using this as a guide, the line was written and the process repeated for each line, taking care not to blot the wet ink.

8 THE GOLD LETTER was burnished when dry. Margins were chosen by placing L-shaped mounting boards at the edges. The base margin was left deeper to provide visual balance.

1 TWO ALTERNATIVE LAYOUTS were explored using the same x-height writing lines but substituting different pens: a heavy size 1½ nib and a skeleton size 5 nib. Although exaggerated, there are many possibilities between extremes of weight and the 'normal' weight, to create various moods.

2 AN INFORMAL italic capital was tried in a centred layout and with very little interlinear space, using nib 2½. To add interest, tiny lines of italic repeating 'Gaudeamus igitur' were added in three places. The text was written in the 'youthful' colours turquoise and green, in watercolour with subtle colour changing. The smaller writing was completed in gold using a 5 nib.

7 WITH GOLD PAINT stirred well and used quite thinly in a 1½ nib, the initial 'G' was added over a light pencil guide line.

Gaudeamus igitur
Juvenes dum sumus.
Post jucundam juventutum,
Post molestam senectutum,
Nos habebit humus.

The Latin poem, Gaudeamus igitur, *written in a foundational hand.*

Alphabet design

2

An arrangement of the letters of the alphabet, whether upper-case, lower-case or a combination of both, is an effective way of introducing colour and texture. Without the restriction of word meaning, letters can be explored as abstract patterns in relation to one another, and a purely decorative panel may be created.

Begin by experimenting with a square-ended brush (say ¼ inch/6.3mm) or an automatic pen with a wash of black gouache. Numerous layouts will suggest themselves – horizontal lines, vertical columns in rows of three or four letters, rectangular or free-ranging edges, oval or circular arrangements.

Observe the spaces formed as the letters combine by cutting down the interlinear space. Extend the ascenders and descenders to tie letters together and note the effect of overlapping strokes. Darker letters can also be written over the washes in a denser mix of gouache and a smaller pen size (round hand 4 or 5). Italic flourished and swashed letters are particularly effective.

Having chosen two or three successful layouts extend your range of materials – bamboo pens, double-stroke automatic pens, even ruling pens may be tried. Use colour in the pen or add a texture to masking fluid with watercolour washes or sponging, with close-toned or complementary colours. In this example, small gold leaf letters were added to the final layout.

MATERIALS

- PEN WITH ROUND HAND NIB 4 OR 5
- TWO STROKE AUTOMATIC PEN SIZE 8
- SQUARE-ENDED BRUSH, ¼ INCH (6.3MM)
- BAMBOO PEN
- MASKING FLUID
- OLD BRUSH
- JAR OF CLEAN, HOT WATER
- GOUACHE OR WATERCOLOURS – BLACK, MAGENTA AND WINDSOR BLUE USED
- NATURAL SPONGE
- LAYOUT PAPER
- ZERKALL PAPER (ARCHES, SAUNDERS OR FABRIANO WOULD ALSO DO)
- TRACING PAPER
- RULER
- H AND 2B PENCILS
- MASKING TAPE
- GUM AMMONIAC CRYSTALS
- OLD TIGHTS
- HOT WATER
- CLEAN JAR
- SOFT PENCIL ERASER
- GOLD LEAF
- GLASSINE PAPER
- BURNISHER

2 HAVING CHOSEN a design, a more finished rough was prepared to establish the correct line spacing. A tracing was made with ruled lines and the letters traced as skeleton outlines.

3 RETURNING TO the black and white rough, an A3 sheet of Zerkall paper was placed over it and the letters traced through directly using masking fluid and a double-stroke automatic pen. (Apply the masking fluid to the back of the nib with an old brush and rinse both frequently in hot water.) This was allowed to dry.

1 VARIOUS ARRANGEMENTS of chosen hands were tried in upper- and lower-cases, using watery black gouache and a ¼ inch square-ended brush on layout paper. Small letters were written into the spaces with a round hand no. 4 nib and a thicker mix of the gouache. Extended flourishes were used to overlap the larger strokes.

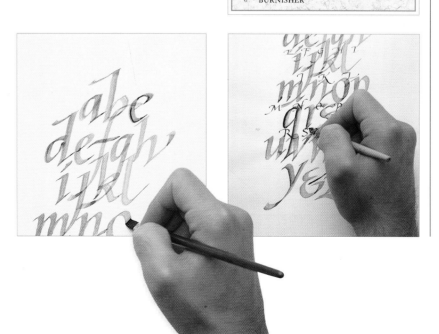

4 COLOURS WHICH blended well were chosen, and fairly dry mixes of magenta and Windsor blue gouache made up in a palette. A wetted and squeezed out natural sponge was dabbed into the colours and this was applied to the paper. Care was taken to cover the letters properly, but an uneven texture and colour mixture were encouraged. Experiments were tried with different effects at this stage.

7 THE SPONGING process was repeated with reference to the colour rough, although an exact copy is not necessary. It was decided to write the capitals in gold this time, and the masking fluid was removed as before to prepare for this process. The swash letters were traced on in pencil.

5 WHEN THE paint was dry the masking fluid was removed with a soft pencil eraser, taking care not to smear colour across the reserved paper. With a dark mix of the two colours, the small swash capitals were written over the sponged areas using the size 4 nib.

6 THE TRACING was taken and by drawing on the back, then through the front, the image was transferred lightly onto the final piece of Zerkall paper. The letters were written over in masking fluid.

8 WITH THE size 4 nib, the swash capitals were written over the sponging in gum ammoniac, made up in accordance with the instructions given on pp 16–17. This was difficult to see and it was necessary to rely on the shine of the wet liquid.

9 WHEN DRY, the letters were gilded, breathing lightly to moisten the gum size but not make the paint sticky or cockle the paper. Transfer leaf was pressed well onto each letter and when set the gold only was burnished through glassine paper. Excess gold was brushed away and dry ungilded areas repaired.

An alternative alphabet design was executed with a paint brush in wide italic capitals. Small lower-case letters with long ascenders, descenders and serifs were written over in a size 4 nib.

The finished alphabet design (steps described on pages 91 and 92) makes an abstract decorative work, although each letter can be clearly distinguished.

In a third design, an alphabet of compressed italic with angular arches and serifs was written out in two lines with minimal interlinear space. This was written out again with a size 3A automatic pen filled with alternating green and blue watercolour.

Bookplate design

A bookplate design combines simple italic calligraphy with flourish design, a decorative border and some illustration, also made with the broad-edged pen.

There is a rich history of decorative bookplates to provide a source of inspiration. The words *'ex libris'* – Latin for 'from the book of' are frequently prominent and have given their name to the genre itself. Coats of arms and books are often incorporated into a bookplate, as well as illustrations of favourite things or even buildings and animals. This design leaves a line allowing the owner's name to be filled in, but this could easily be incorporated into the design.

The bookplate has been designed at A6 size in order to be reduced mechanically to A7 (about 70 per cent). Reduction will enhance the crispness of calligraphic forms but if carried too far the letters will be distorted, as they will if enlarged. If possible, try your reduction on a photocopier before the final stages, so that any adjustments can be made.

The final artwork may be taken to a printer (protected with clean layout paper taped onto the back with masking tape) who will make a PMT (photo-mechanical transfer) of the image at the required size. This will be used to print from on paper of your choice and the results may be trimmed to size. Ready-gummed papers are available, or the bookplates may be pasted lightly into your books.

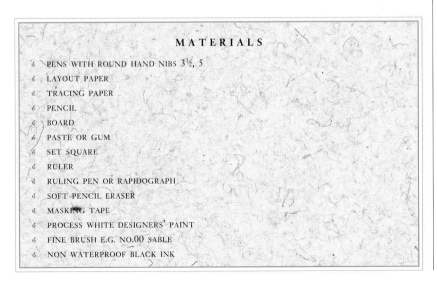

MATERIALS

- PENS WITH ROUND HAND NIBS 3½, 5
- LAYOUT PAPER
- TRACING PAPER
- PENCIL
- BOARD
- PASTE OR GUM
- SET SQUARE
- RULER
- RULING PEN OR RAPIDOGRAPH
- SOFT PENCIL ERASER
- MASKING TAPE
- PROCESS WHITE DESIGNERS' PAINT
- FINE BRUSH E.G. NO.00 SABLE
- NON WATERPROOF BLACK INK

1 TO BEGIN with, the words *'ex libris'* were written in italic upper- and lower-case using a nib size 3½ to establish the decorative possibilities. These included the initial 'E', the top and tail of upper-case 'L' and the repeated ascenders of 'b' and 'l'. The flourish ideas were developed using layout paper and tracing through.

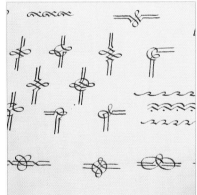

2 SOME DECORATIVE borders were attempted in size 5 nib. The repeat patterns were rather monotonous and it was decided to use flourishing, with a double line breaking out into knots at intervals. These were sketched in pencil then worked out with pen. Some illustrations were also tried and a schematized open book was chosen.

3 THE ELEMENTS were traced through layout paper to produce a rough idea of the collected ensemble. It was noticed that the words *'ex libris'* could be smaller and more flowing and the flourishes of the border should be reduced and simplified. With cut out paper patches pasted over, elements can be remedied at this stage.

4 A WORKING rough was prepared. An equal distance was measured from the edge on three sides of the space with one and a half times as much at the bottom. Parallel lines were drawn using a set square with the bevel slanting towards the paper, so the ink would not run underneath. The elements were drawn into the grid.

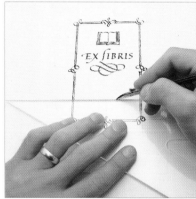

5 A TRACING was made from the final rough and transferred onto another piece of layout paper by drawing on the back in pencil and again from the front. The words *'ex libris'* were written before too much detail was added, as this was the most important and 'chancy' element. Then the book was added and the border lines ruled in, leaving spaces for the flourishes.

6 THE BORDER flourishes were inserted with the pen angle constant. With a fine ruling pen, a line for the name was drawn in the lower space. A rapidograph would do as well.

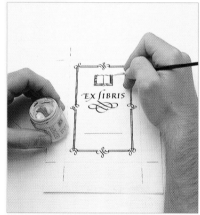

7 WITH THE same pen, marks were ruled at the corners, but away from the edge of the work, to show the printer where to cut the bookplates. (For a card, the fold is indicated by a similar but broken or dotted line.) With a soft pencil eraser the pencil lines were removed and any untidy edges sharpened with a fine brush and process white. It may be sensible to mount the artwork onto a board but check with the printer, who may prefer it left flexible.

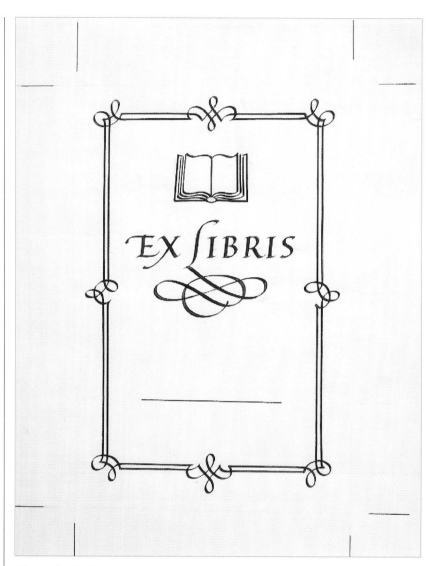

The completed bookplate design can be printed on paper of your choice.

Greetings card

4 The language of love may be universal, but there are different words for 'love' in a host of different languages. The Latin word *'amor'* is widely understood, however, and this was chosen as the centrepiece for a greetings card.

Making a card is an instant and creative use of calligraphy, and a handmade one is far more personal. This example uses a single word with added decoration, and a border composed of words written in a similar style. In this case *'amor'*, which also means 'love' in Spanish and Portuguese, is accompanied by the same word in a variety of other languages – clockwise from top left: English, Gaelic, Danish, Spanish, German, Swedish, Italian, Norwegian, Welsh, Dutch and French. With the accompanying emblems of love in the border and letters – the hearts and kisses, the card would make a suitable Valentine, anniversary card or lover's gift. However, the idea could be easily adapted, using a name, perhaps with its meaning around the edge, or another word such as 'Noel' or 'congratulations'.

Working on a coloured background gives the words a different effect, but the paint colour must be modified to provide sufficient contrast, where legibility is required. The completed panel may be mounted on a larger, thicker piece of card, allowing the necessary depth for its fold and backing.

MATERIALS

- AUTOMATIC PEN SIZE 4
- PENS WITH ROUND HAND NIBS SIZES 3, 3½ AND 5
- ¼ INCH (6.3MM) BRUSH
- GOUACHE PAINT – LAMP BLACK, SCARLET LAKE AND ZINC WHITE
- PROCESS WHITE DESIGNERS' PAINT
- GOLD PAINT
- INGRES GREY AND CANSON M.I. TEINTES PAPER
- LAYOUT PAPER
- RULER
- PENCIL
- TRACING PAPER
- FILLING BRUSH
- SABLE WATERCOLOUR BRUSH, SIZE 00
- SCISSORS
- 'COW' GUM
- WHITE CARD
- BURNISHER
- PVA GLUE

2 A SUITABLE half uncial alphabet was devised with a more natural pen angle than the usual horizontal, and a slight forward slope – partly half uncial, partly foundational. An x-height of three nib widths was used with a round hand size 3 and an automatic pen size 4, in black ink on layout paper.

3 THE WORDS for love were written out, aiming to arrange them in two equal rows with two single words of similar length, and alternating words with a different visual pattern. These were pasted around the word *'amor'*, which was decorated with a size 5 nib in freely written flourishes. The border was rewritten smaller, and arranged on the paste-up.

1 USING A ¼ inch (6.3mm) brush and watery black gouache on layout paper, the word *'amor'* was tried out in various styles to establish a pleasing design in uncials. The idea of a border of smaller words and pen-made decoration over the letters was also explored.

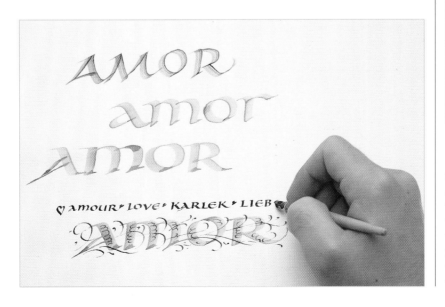

4 EXPERIMENTS WERE made on grey paper using a liquid mix of gouache in zinc white and scarlet lake. Small letters in white and gold were also tried, and the contrast on the Ingres paper was insufficient, so Canson was tried. The automatic pen wrote more crisply when held upside down, with the bevel sloping upwards away from the paper. Flourishes were roughed out, to fill the spaces evenly.

6 THE WORD *'amor'* was written more than once with the pink gouache. When a satisfactory version was achieved, the rest of the detail – the flourishes and the beginning of each small word – was traced down.

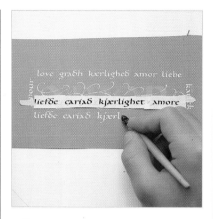

8 THE SMALL words for love were written with process white and the size 3 nib, using the cut-out black and white versions taped above each line as a guide.

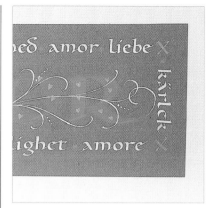

9 AN 'X' was written in each corner with gold gouache in a thin consistency but well stirred, and a size 3 nib. Finally, with a 00 watercolour brush small hearts were painted in gold between the words and along the wide parts of each letter. When this had dried, a light burnish was applied carefully onto the gold only, so as not to shine the surrounding paint.

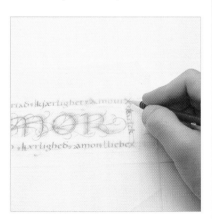

5 THE FINISHED rough on layout paper was traced with skeleton letters *'amor'* and the beginning of each small word marked. This was transferred with evenly spaced lines onto the final grey paper, but without too much other detail.

7 THE FLOURISHES were added in process white with a size 5 nib, testing the flow first on a scrap. To activate the flow, it was sometimes necessary to dip the very tip of the pen in clear water. The inconsistency of the strokes became a pleasing feature.

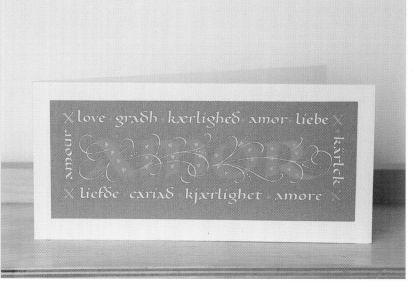

A multi-lingual greetings card with a message of love.

Monogram design

5 A monogram is a decorative combination of two or more initials with a variety of applications. They may be used to personalize a gift for a wedding, anniversary or baby's christening; monograms are also an attractive addition to stationery – letterheadings, invitations and orders of service; they may be illuminated on cards and other panels or engraved on glass, silver and signet rings.

Many writing hands may be tried, but some work better than others. Only by laying out the available letter material can the best and most suitable possibilities be considered. For example, black letter capitals are asymmetrical and individually complex, so should not be overlapped. Copperplate, italic and swash capitals are often best, but formal roman and versal characters may also be used and given decorative themes in medieval, Tudor and Victorian styles. Bear in mind the mood you wish to convey – the monogram should be light and flourished for celebrations, formal and upright for more serious purposes and clearer legibility.

Also consider the final shape you require – whether irregular or one which comfortably fills a rectangle, square, oval or circle. Bear in mind the overall shape and style of an existing object the monogram will be applied to.

Remember that the simplest and most legible solution is often best. Letters should usually be read in a particular order which must come across clearly. The most successful arrangement of letters is usually to have them in a row, or to extract the second or third letter and place it below the other two.

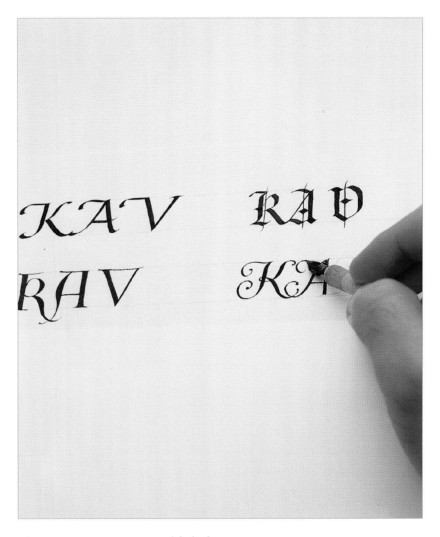

MATERIALS

- ROUND HAND PENS IN VARIOUS SIZES, DEPENDING ON SIZE AND STYLE (ALSO TRY BRUSHES, BAMBOO AND AUTOMATIC PENS)
- INDIAN INK – NON-WATERPROOF
- BLACK GOUACHE
- FILLING BRUSH
- LAYOUT PAPER

1 THE MONOGRAMS raw material, the letters 'KAV', were drawn out in different letter forms but with the letters unconnected. Black letter and Celtic capitals were too complex and dissimilar to be combined successfully. The flourished tails of swash italic and copperplate could provide elements useful in such a design. Also, the repeated diagonals could be brought out in the formal styles of roman, versal and uncial. And 'A' has a straight-backed form in Lombardic which can be used to balance 'K'. In general, 'V' is less variable than the other letters.

2 SIMPLE ARRANGEMENTS were sketched in pencil as a sheet of thumbnail ideas. Inspiration was also sought from historical examples, particularly those found in a Victorian 'Crest Album' collected from letterheadings of the time.

ROMAN SCRIPT

Roman capitals are the basis for formal monogram design. To begin with, the letters were arranged in a simple row and various elements overlapped to adjust the distribution of space evenly. Then the 'A' and 'V' were placed on top of each other and the angles of 'K' related, although this made the reading order unclear. Finally the 'A' was dropped and 'K''s tail used to form its cross bar, until a legible combination with balanced spaces was achieved.

3 EXPERIMENTATION WAS begun in the chosen styles, using a broad-edged pen or brush on layout paper. Simple arrangements led to more complex combinations. The ideas that developed were traced through layout paper until satisfactory designs were reached.

SWASH ITALIC CAPITALS

Swash italic capitals are written with single pen strokes and give some of the flexibility of copperplate combinations, with their extended tails and flourishes. Note how the ideas grew from each other, although sometimes at the expense of legibility.

UNCIAL SCRIPT

The uncial monograms provided interest in the heavy contrast of diagonals. The final solution had an almost oriental look and this suggested a further treatment – using a flat brush with a dry paint to create a textured appearance.

VERSALS

Versals are more flexible than roman capitals and can form quite abstract combinations. They are formed with double strokes which may be left unfilled for contrast. By cutting out 'bites' from the serifs and adding decorative dots and diamonds, Tudor-style effects may be created.

COPPERPLATE SCRIPT

The copperplate capitals were designed using double strokes for the thicker stems. The first ideas followed on from the roman combinations, but the greater flexibility of curved and flourished letters provided more balanced compositions. Decorations were added with small strokes growing organically from the curves. The other combinations were achieved by distorting and emphasizing portions of the letters. The lighter flourishes can overlap and tie the forms together, but try to avoid more than two strokes crossing at any one point.

Clock face

6 Circular clock faces have been current since the Middle Ages, with twelve or twenty-four numerals arranged evenly around the perimeter. At first Roman numerals were used but eventually, by the seventeenth century, Arabic numbers were also common. In this project, the two styles are combined in different colours and weights of pen. Instant legibility is of course essential for this purpose, so the delicacy of the five-lined music pen contrasts with the heavy single strokes in a darker colour. The use of nearly complementary colours – green and purple – also helps emphasize their contrast.

Careful planning is necessary to distribute the numerals evenly around the circle, particularly as they are upright. In the Roman system there are great differences between the short numerals I and V and the compound VIII and XII. To tie them together, two concentric gold lines were drawn around the clock face. Finally, to add further interest at the centre, the monogram 'T.F.' was written using the music pen. This stands for *'tempus fugit'* or 'time flies'.

The completed clock face had paper hands made for it and attached with a brass pin to create a moveable decoration for a child's room.

MATERIALS

- FIVE-LINE NIB MUSIC PEN OR FIVE-LINE AUTOMATIC PEN
- AUTOMATIC PEN, SIZE 3
- GOUACHE PAINT – LAMP BLACK, OXIDE OF CHROMIUM, LIGHT PURPLE, ULTRAMARINE, ZINC WHITE, IMITATION GOLD
- LAYOUT PAPER, TRACING PAPER
- OLD PAINT BRUSH
- B.F.K. RIVES GRIS
- INDIAN INK – NON-WATERPROOF
- SCISSORS, 'COW' GUM
- PENCIL, RULER
- COMPASSES WITH RULING PEN ATTACHMENT
- GUM AMMONIAC GOLD SIZE
- GOLD LEAF (TRANSFER ILLUMINATING SINGLE THICKNESS)
- BURNISHER, GLASSINE PAPER
- NO. 00 SABLE BRUSH
- CARD AND SCALPEL

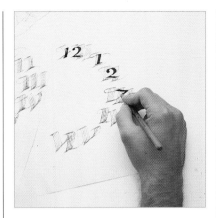

1 VARIOUS ROUGH ideas for the numerals were tried freehand on layout paper, using a broad-edged brush and watery black gouache. A rejected idea was to radiate the numerals around the circumference but this proved unbalanced and hard to read. To achieve the lightness required, the Roman numerals were written in a music pen and a flourish was added with the left corner of the nib. The Arabic numbers were written in a heavy size 3 automatic pen.

2 AN APPROPRIATE size was chosen, 7½ inches (19cm) diameter with a band 1¼ inch (32mm) wide inside the circumference, and a centre line to place the numerals. With compasses set at the radius, the circle was divided into six, then twelve segments. The numerals were written at the intersections. This caused overcrowding around XI and XII, and VII and VI, so some adjustments were made.

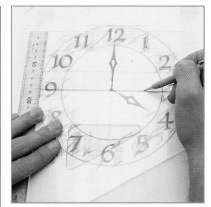

3 USING LAYOUT paper a finished rough was made from the previous stage using consistent measurements for the writing lines, although the interlinear spaces varied significantly. The Arabic numerals were slightly reduced in size. It was also decided to draw lines with a ruling pen in compasses to define the outer rings. A tracing was made in pencil with skeleton letters and numbers at this stage.

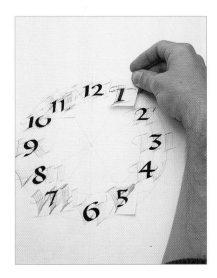

4 A NEUTRAL grey Rives paper was chosen and the complementary colours green and purple. Oxide of chromium was used for the green and a mix of ultramarine and light purple for the violet, in a thin creamy consistency applied with an old brush to the pens. The paint flowed adequately through the pens, although the sharpness of the music pen caused the rough surface of the paper to catch a little.

5 HAVING TRIED the circles in gold, and some hands, it was felt that the centre could be enlivened so a monogram, 'T.F.' was devised with the music pen and tried in both colours before settling on the green. Some final adjustments to the placing of the numerals were also noted.

6 THE LINES and skeleton letters were traced down for the final version on the Rives paper. The numerals were written first, from top to bottom rather than clockwise to avoid smudging. The monogram 'T.F.' was also written at this stage.

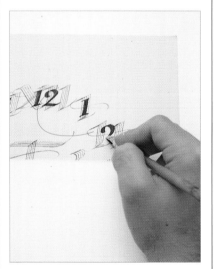

7 THE PURPLE numbers were written over the green, using the size 3 automatic pen.

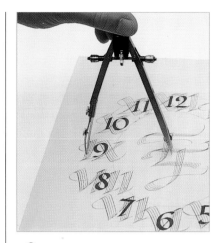

8 USING THE compasses and ruling pen (springbow) attachment, the concentric circles were ruled in liquid gum ammoniac size. A second layer was added carefully while wet.

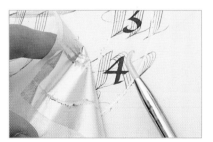

9 GOLD TRANSFER leaf was laid onto the dried size after half an hour. The adhesion was obtained with one breath just before applying the gold, then burnishing lightly on the back of the transfer paper. After a further wait of quarter of an hour, a burnish was given to the gold through glassine paper and the excess brushed away. Because of the soft texture of the paper, the size ran a little into the numerals and caused the rings to merge very slightly, so these were overpainted carefully with gouache and a size 00 sable brush.

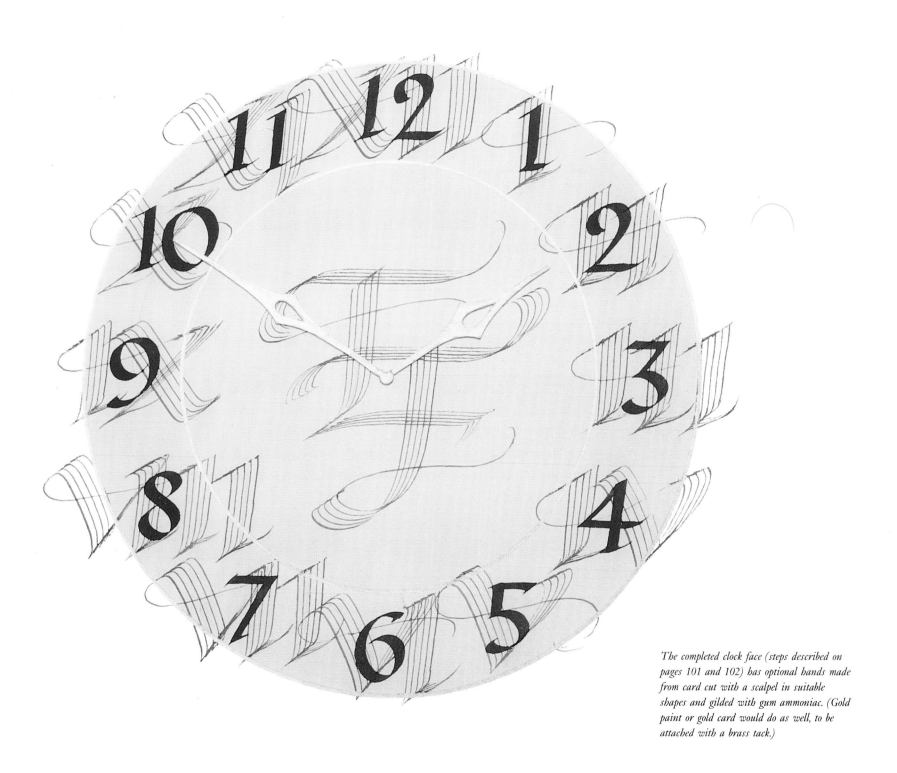

The completed clock face (steps described on pages 101 and 102) has optional hands made from card cut with a scalpel in suitable shapes and gilded with gum ammoniac. (Gold paint or gold card would do as well, to be attached with a brass tack.)

Index